CHESTERTON, APEDALE, KNUTTON & SILVERDALE

THROUGH TIME

Tony Lancaster

AMBERLEY PUBLISHING

Acknowledgements

My special thanks to Brenda Dyble for so much help on Chesterton and Apedale; to Ann Allen and Sid Higgins for help on Knutton: they were so generous with their time and their photograph collections. Then there were: Barrie Collinson (especially his photographs of Apedale), Phil Robinson (the Moseley Railway Trust), Pete Wells, Dave Rushton and all the volunteers at Apedale Heritage Centre, Terry O'Neil, Bill Hughes, Tony Gumley, Paul Niblett, Terry Brooks, Glynn Moore, Mick Downs, Barbara Mottram, Jane Sheldon – all helped so willingly.

All my efforts would have been in vain without the endless patience and great technical skill of Linda Forrester. Jane's camera skills and ability to put up with the traumas of book writing were once again vital. Then there was the support of Sarah, Ruth, Katie, Emma and Mick.

The following books were very useful; David Dyble, *A History of Apedale and Chesterton* (2002) is a mine of information; H. Brown, *Most Splendid of Men* (1981); A. C. Baker and M. G. Fell, *Newcastle-under-Lyme:its Railway and Canal History* (2009); J. Holliday, *Silverdale People* (1996); G. Bebbington (2010); P. Dfeakin, *Collieries in the North Staffordshire Coalfield* (2004); A. D. M. Phillips (ed.), *The Potteries* (1993); D. & B. Morris, T. & J. Priestly, R. Simmons, E. Watkin, *Newcastle-under-Lyme & District* (1998).

First published 2012

Amberley Publishing
The Hill, Stroud, Gloucestershire, GL5 4EP
www.amberley-books.com

Copyright © Tony Lancaster, 2012

The right of Tony Lancaster to be identified as the Author of this work has been asserted in accordance with the Copyrights, Designs and Patents Act 1988.

ISBN 978 1 4456 0994 2 (print)

British Library Cataloguing in Publication Data.
A catalogue record for this book is available from the British Library.

Typesetting by Amberley Publishing.
Printed in Great Britain.

Introduction

At first sight, there seems nothing in particular to distinguish the three North Staffordshire villages of Chesterton and Apedale, Knutton, and Silverdale. They are all now part of the borough of Newcastle-under-Lyme and appear as residential, dormitory areas to that town. Much of the housing has clearly been built after 1945. There are a number of industrial estates and manufacturing units around the villages, which are also surrounded by some attractive countryside into which it is easy to walk. There is no obvious evidence to be seen of periods earlier than the nineteenth century – no medieval churches or manor houses. There are no buildings to indicate that Knutton was a medieval settlement – Clotone in the Domesday Book. There is only archaeological evidence to show that Chesterton was a significant Roman settlement.

There is, however, a much more interesting picture to be found by a closer examination of the area. The three villages played a major part in the development of North Staffordshire's industrial strength in the nineteenth century. The area was rich in the two basic requirements of industrial change at that time – coal and iron. All three villages grew as numerous coal mines were developed around them. All three villages had substantial ironworks. Another important industry was brick and tile making. Almost all this heavy industry has disappeared, leaving a rich store of photographs but only a few monuments. Only careful detective work can reveal the clues to these three industrial communities.

There are references to the coal and iron industries in this area in the seventeenth century. Dr Plot (*The Natural History of Staffordshire*, 1686) inspected a 'footerill' (mine taking coal from near the surface) in Apedale in 1677. Coal was used in the salt industry in Cheshire and by nail makers and other metalworkers. By the end of the eighteenth century, coke was replacing charcoal to smelt iron ore, steam engines were in increasing use and the pottery industry was expanding. 'Coal output was rising significantly between 1750 and 1840 ... total production was approaching 1 million tons by 1836' (P. Lead, *The Potteries*). The most striking development was the depth at which coal was mined, helped by the use of steam pumps; Burley Pit in Apedale had workings at a depth of over 2,000 feet in 1836. The iron industry, which had declined in North Staffordshire in the eighteenth century, was revived in the 1790s by two main concerns: the Parker Brothers Ironworks in Apedale (1785) and the Silverdale Iron Company (1792).

It was the big landowners of the area who leased out their lands for these developments in the coal and iron industries. They then drew revenue from the coal and iron that was produced,

usually working through agents. In Apedale, Sir Nigel Gresley began the exploitation of the minerals in the area and financed the building of what became known as the Gresley Canal to transport coal from Apedale to Newcastle-under-Lyme. In the 1790s, most of Gresley's estate passed to the Heathcote family, who then held it until, in 1931, it was sold up. In Silverdale and Knutton, it was the Sneyds of Keele Hall who leased out their lands and were responsible for the first rail link from Silverdale to Newcastle-under-Lyme.

In 1848, Ralph Sneyd leased his mines and ironworks to Francis Stanier, a Newcastle solicitor. He was to play a major part in the expanding industries of all three villages. Between 1851 and 1864 Stanier took control of the ironworks of Silverdale, Knutton and Apedale, creating an industrial empire that lasted until 1890. During this period, coal production increased; 'A peak of production was achieved of little short of 7 million tons per annum in 1907' (J. H. H. Briggs, *The Potteries*). Large quantities of bricks and tiles were produced in the area, another industry to use the local coal. This industrial expansion would not have been possible without improved transport. This was provided by the railways which, during the second half of the nineteenth century, linked these centres of industry. It was the North Staffordshire Railway which provided these links between the three villages and beyond. And, of course, railways were great consumers of iron and coal.

The effects of such industrial expansion on the communities of Chesterton and Apedale, Knutton, and Silverdale were immense. Population grew rapidly; for example, Silverdale's population in 1851 was about 2,000, but twenty years later, it was about 6,000. In the wider area to which the three villages belonged – the Wolstanton Urban District – population grew from about 5,000 to about 23,000 in the fifty years between 1851 and 1901. There still remain many clues to this expansion 'on the ground'. There are three Victorian churches, though very few of the many Methodist chapels remain. There are still many late nineteenth- and early twentieth-century terraces of working-class houses. There are some of the early school buildings and some reminders of the sports and pastimes of an earlier period. Then there are the memorials that remind us of the hazards of heavy industries, particularly coal mining.

The twentieth century saw considerable changes in all three communities. The iron industry did not survive the depression years of the 1920s and 1930s. Coal mining lasted longer, though in fewer, deeper mines. The last colliery to close was Silverdale Pit in 1998. Bricks and tiles continue to be made, but many works have closed. Business parks and housing estates have replaced many of the industrial sites. Land reclamation has seen the 'greening' of areas and the formation of nature parks at Apedale and Silverdale. The railways have gone and the motorcar dominates the transport scene, enabling people to get to work but clogging the roads with traffic. Shops and businesses in the villages struggle against the competition of out-of-town supermarkets and other large stores. There is change but also some continuity in terms of community activities.

The book is intended to take the reader on a journey through the three villages. It starts on the route of the old toll-road, north from Newcastle-under-Lyme. It then wends its way through Chesterton and Apedale, Knutton, and finally Silverdale. There are stops and deviations on the way to look at the many aspects – economic, social, religious, educational and cultural – of lives in the three villages that have changed through time.

Chesterton

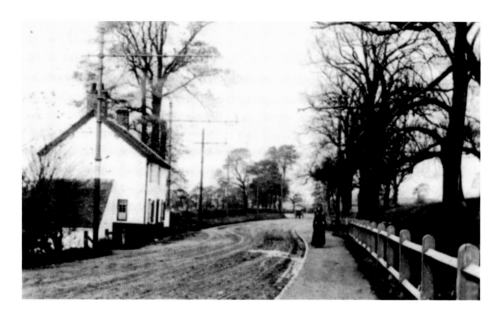

Entering Chesterton

The journey in this book starts by following the first turnpike road in Staffordshire, built in 1714. The old photograph shows this road, which ran from Tittensor, south of Newcastle-under-Lyme, to Talke to the north via Chesterton. On the left is a toll-house, now the site of an abandoned hotel. The road turns to the left in the middle distance. It then went through Chesterton, climbed Crackley Bank to Red Street and Talke. The rural aspect of the road has disappeared, replaced by the busy, modern dual carriageway, the A34, which now takes the traffic directly to the north. The sign indicates the branch to Chesterton.

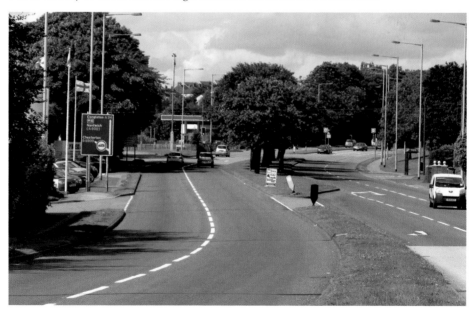

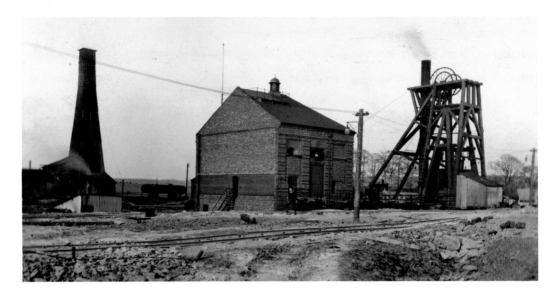

Holditch Colliery

Holditch Colliery was 'a new, all twentieth-century pit where production began in the latter stages of the First World War' (D. Dyble, p. 125). Ironically, the exploratory work for the pit was done by a German firm, whose engineers were arrested and interned as they were trying to leave the country in August 1914. Holditch Colliery, known locally as Brymbo, continued production until it closed in 1989, when it still employed 700 miners. The modern photograph, taken from Apedale, shows only a spoil heap that remained after Holditch Colliery closed in 1989. Now the colliery site has become a large industrial estate. The Holditch area has another significance for Chesterton history; excavations have shown that it was the site of a Roman settlement in the first and second centuries AD.

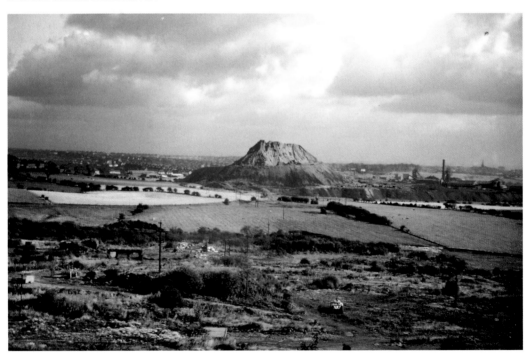

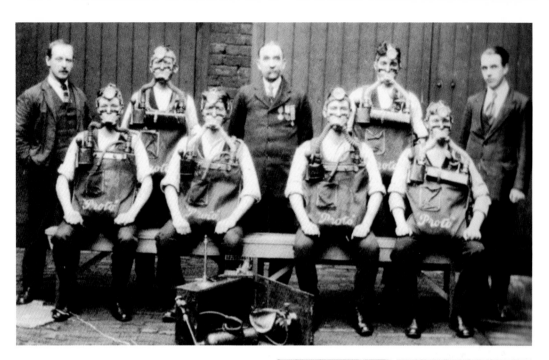

The Holditch Colliery Disaster, 2 July 1937

Accidents and disasters became all too frequent in the history of coal mining in North Staffordshire in the nineteenth and early twentieth centuries. The Holditch disaster was more recent. The report on the disaster showed that the heavy loss of life was the result of three incidents: a fire and an explosion, leading to three deaths, followed by 'a devastating explosion, which caused the holocaust of twenty-seven lives'. The memorial to the miners who died stands outside the nearby Apedale Heritage Centre. The old photograph shows a Holditch mine rescue team demonstrating new safety equipment. The report on the 1937 disaster praised the 'exceptional merit' of the efforts of the safety team of that time.

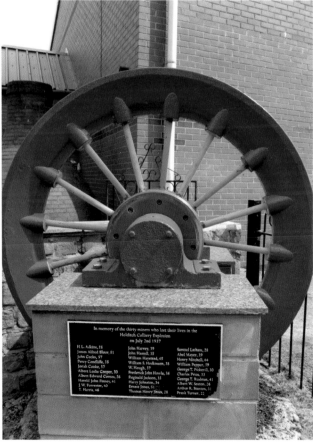

The Hollows, London Road I

The Hollows (named after an earlier farm) is now a busy roundabout for traffic going in five directions. However, as the two photographs show, some of the buildings of 1910 still remain, in spite of modern development on both sides of the road. The terrace on the left remains. To its left, a house with a timbered gable, the Mount, is visible in both pictures. This belonged to the Downing family, prominent in the local brick and tile industries. The open area to the right has disappeared under buildings and tarmac.

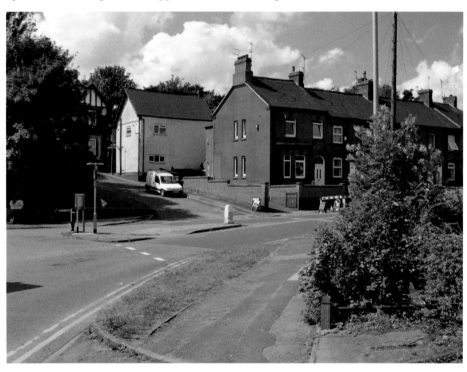

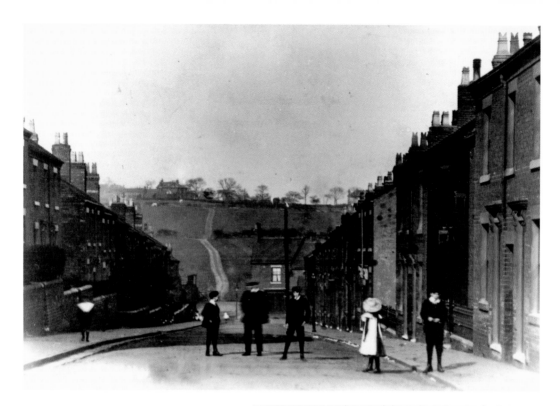

Warwick Street, Off Castle Street
The people in the early picture stand at the top of Warwick Street. The distant view before them is one of hills and green fields. That same view today is dominated by the houses of the Beasley estate. A large amount of housing in Chesterton was built in the 1930s and after 1945. Warwick Street has retained most of its terraced housing, interestingly built in pairs.

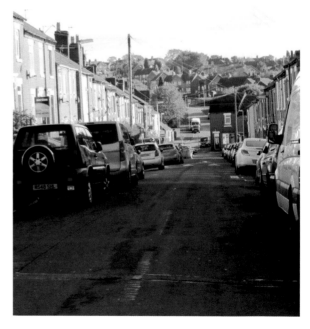

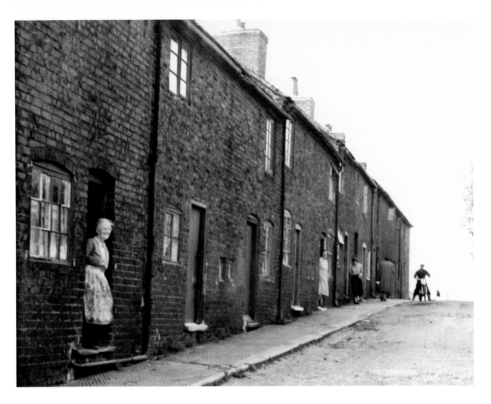

Mount Pleasant, Castle Street

'A Roman Fort lay at the top of Mount Pleasant, on a flat-topped hill. It appears to have been occupied in the later first century' (Nicholas Pevsner). The old picture here illustrates a later period of development! The Castle Street area saw housing spread to accommodate the increasing population of the village. Mount Pleasant was one of the streets developed, but, unlike Warwick Street, it has changed beyond recognition.

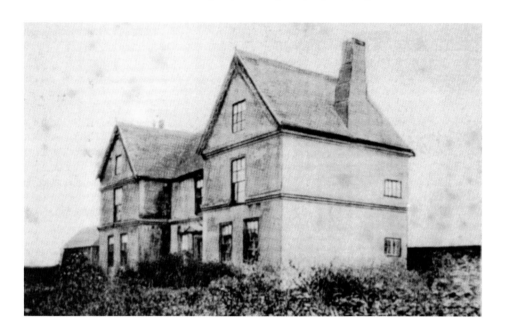

The Old Hall, Castle Street

Chesterton's Old Hall stood on the west side of Castle Street. It was owned originally 'by the Macclesfield family who were prominent Roman Catholics in North Staffordshire' (D. Dyble). Later it became a farmhouse and residence of some of the land agents of the Heathcote estate. Another Chesterton Hall was built (*c.* 1802) on land on the opposite side of Castle Street by a wealthy local businessman, Thomas Kinnersley. The site of this house is now occupied by Chesterton Park, shown in the new picture. The recent photograph also includes a daughter's memorial to her father and all the other miners who died at Holditch Colliery between 1912 and 1989.

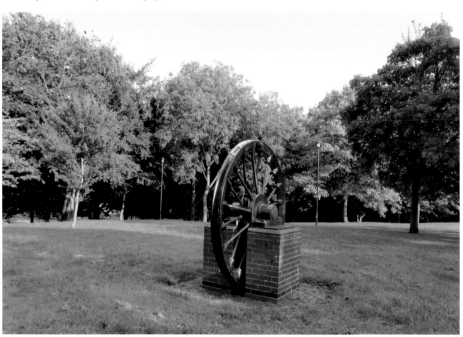

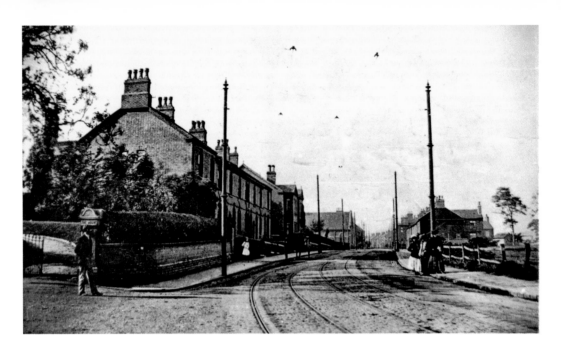

The Hollows, London Road II

Returning to the Hollows, London Road is shown leading into what is now the centre of the village. While the left sides of both pictures show continuity, new buildings have appeared on the right. One survivor on that side is the Grove House Inn (white in the new photograph). Tramlines in the old photograph (*c.* 1910) are a reminder that Chesterton and Silverdale were connected to Newcastle-under-Lyme by tram services, run by the Potteries Electric Tram Company between 1901 and 1926.

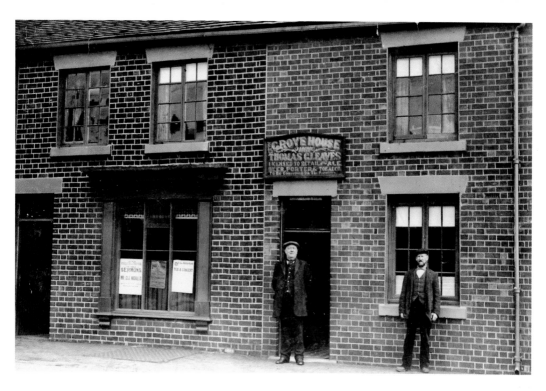

The Grove House

There have obviously been considerable changes to the Grove House in the interval between these two pictures. This public house is one of the few survivors from the time when a trade directory of 1854 listed it and seventeen others in Chesterton.

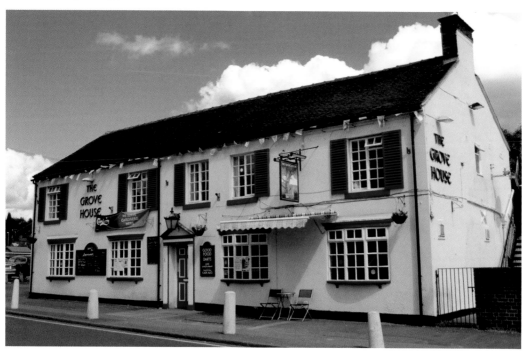

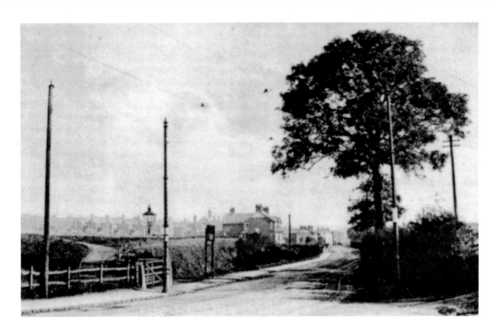

Broadmeadows, *c.* 1910

This is a final view from the Hollows, looking back towards the A34. The old photograph looks towards what was then known as Broadmeadows Infants' School. This became a mixed secondary school in 1931 but is now Churchfields Primary School. The area on the immediate left has changed considerably. The path going off from the gate has become the busy Wolstanton Road. Both sides of the road have been developed up to the modern roundabout and trees, and houses have obscured the old view.

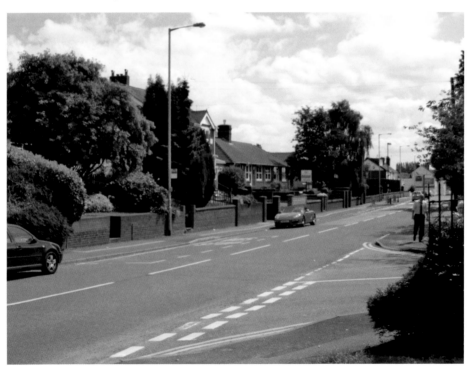

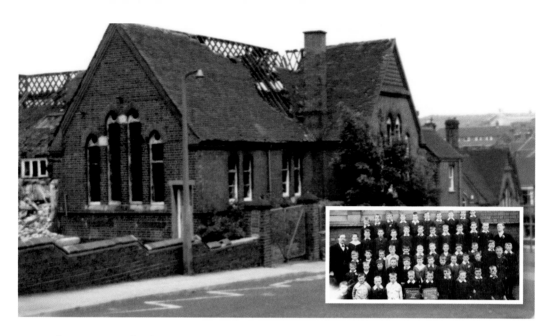

Albert Street Schools

The older picture shows two of the Albert Street schools, built in 1877 and 1884 by Wolstanton School Board (Chesterton was part of the Wolstanton Urban District until it became part of the borough of Newcastle-under-Lyme in 1932). A later infant school was built on the same street, which became known as 'Board School Bank'. The schools were built as a response to rising population, and classes were large, as the inset reveals. Here a well-remembered teacher, James 'Gaffer' Riley, is pictured on the left. He was head of the boys' school from 1882 until 1923! Here the boys' school, situated above the girls', is in the process of demolition in 1986. The large, modern building that has replaced the schools is the Vision Centre, a community facility.

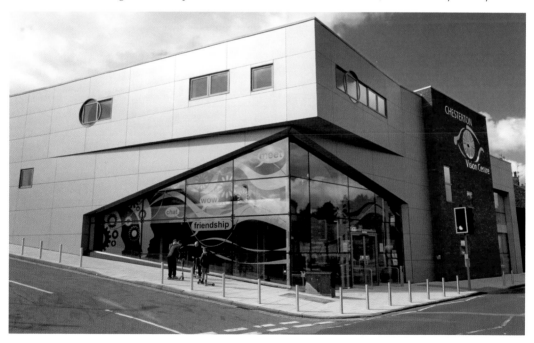

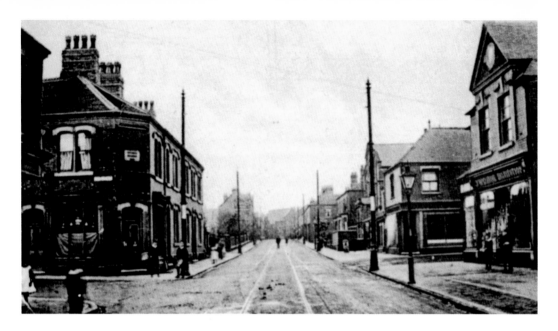

London Road I

This old view of London Road (*c.* 1910) looks down towards Dragon Square from a point just before Victoria Street on the left. A number of buildings, like the Co-operative store on the right, have survived – though it is no longer the Co-op, which has moved to newer premises much further down the road. But, as the new photograph shows, some significant changes have taken place. The large Primitive Methodist chapel on the right and the Wesleyan chapel in the middle distance have gone. The lower end of London Road has changed almost completely.

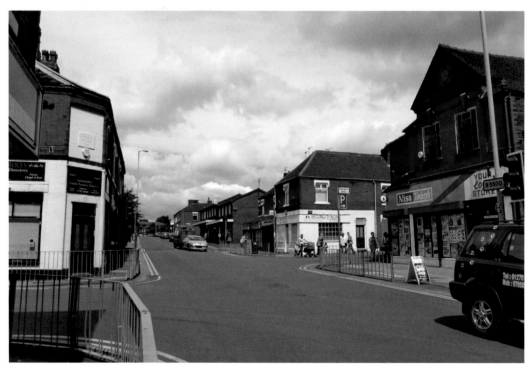

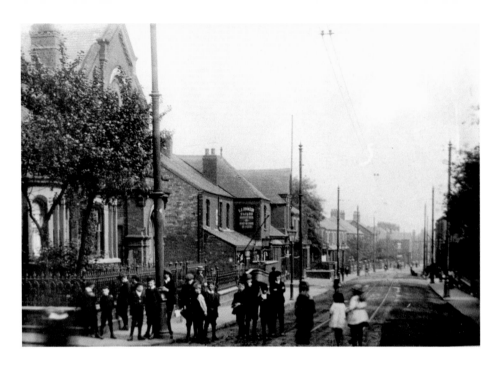

London Road II

This is the reverse view of part of the same scene. The old photograph was taken at about the same time as the one in the previous picture. As so often happened at that time, the photographer has enlivened the picture by including a group of interested children. The houses and chapel on the left have now gone, but as we have seen the old Co-operative building remains. Between that building and the one on the left in the new picture, nothing of the old street remains.

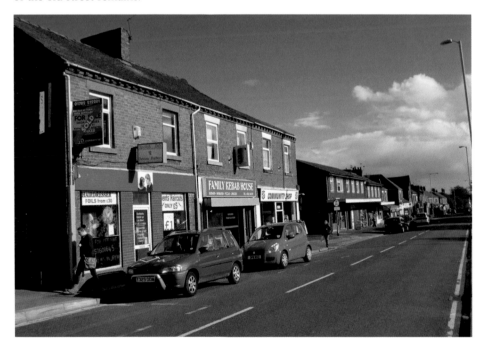

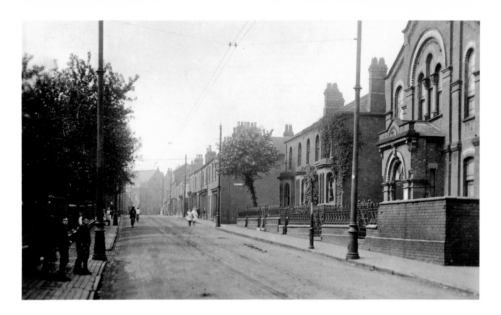

Towards Dragon Square

There have been substantial changes at this end of London Road. In the old photograph, the Wesleyan chapel is in the distance and the Primitive chapel is on the right. The strength of Methodism, particularly Primitive Methodism, in mining areas is shown by the number of chapels in nineteenth-century North Staffordshire communities. Chesterton is only a few miles from Mow Cop, the birthplace of Primitive Methodism. The large and impressive buildings shown here reflect the wide support enjoyed by both sorts of Methodism in the nineteenth century. At present, however, there are no Methodist chapels remaining in Chesterton. The new photograph shows the new parade of shops at the far end of London Road, including the present Co-operative store, which replaced the one opposite Victoria Street.

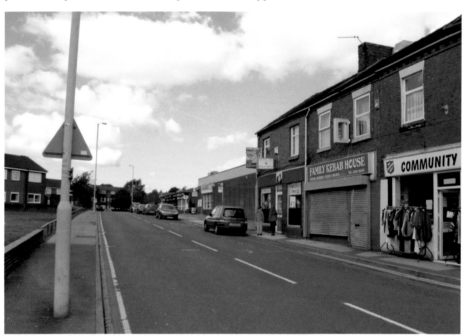

Heathcote Street, London Road

These two pictures show a very different view from the end of Heathcote Street, looking across London Road. The buildings opposite in the old picture appear in a derelict state. Their demolition has opened up a fine view of Holy Trinity church across the grassy area.

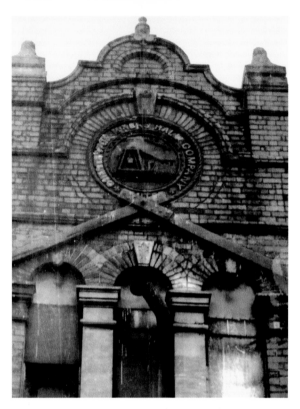

Miners' Hall, Heathcote Street

The Miners' Hall had a chequered history, largely through lack of adequate funds. It was intended to be a Miners' Institute, with educational and recreational functions, including a library, reading rooms and a large meeting room. When building began in 1871, the money soon ran out. After legal arguments, the Hall was built but was described at the time as 'unfinished and comfortless'. The Hall was taken over by the Salvation Army in 1822 and was used by them for the next forty years. Finally, after refurbishment, it became the Alexandra Cinema from 1926 until the 1960s. In the 1970s it was demolished. The only section that has survived is the stone plaque from the façade. It was rescued from a council tip and is now in the Apedale Heritage Centre museum.

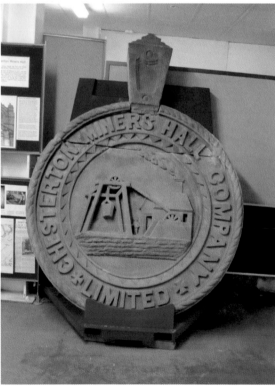

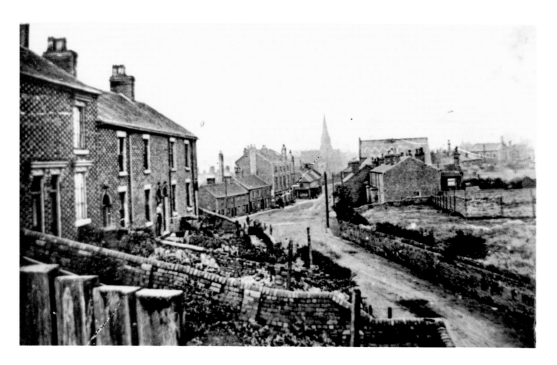

Dragon Square from Crackley Bank

The property to the left of this view has all gone, replaced by modern housing. The same is true of the right. Dragon Square itself now hardly merits the title of 'square'. As well as its Methodist chapel, the old square had the very impressive George and Dragon public house (*inset*). The present area is predominantly residential.

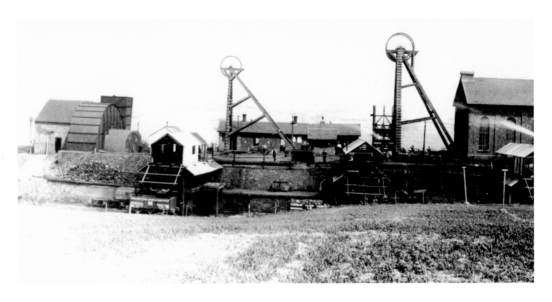

Parkhouse Colliery

Turning from Dragon Square and beginning to climb Crackley Bank, a short deviation to the main A34 takes the present-day traveller to the large Parkhouse Industrial Estate, spreading out on both sides of the main road. Here was the site of Parkhouse Colliery, shown here, from 1874 to its closure in 1968. There were also clay workings and tile works in the area. Work on regenerating the area began in 1975 and, by 1985, 45 hectares of land had been redeveloped and around 4,000 jobs created. The new picture shows a modern brickworks, one of many businesses set up in the area.

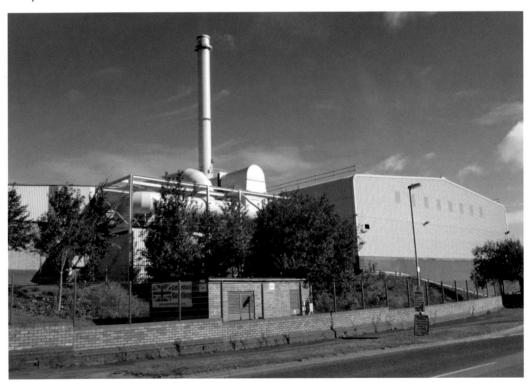

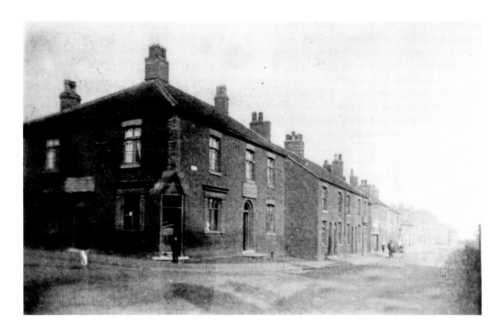

Red Street

From the bottom of Crackley Bank, the old toll-road rises steeply to Red Street on its way to Talke. The steep hill was one reason for the later re-routing of the road to the north. At the top of the hill were two public houses, the Wheatsheaf (now gone) and the Crown, shown in both pictures. The present building dates from the nineteenth century. There were at least two potteries working in Red Street in the eighteenth and nineteenth centuries. One, the Moss Works, was operated from the Crown and its owner is listed as a pottery manufacturer and 'Victualler at the Crown public house' (D. Dyble).

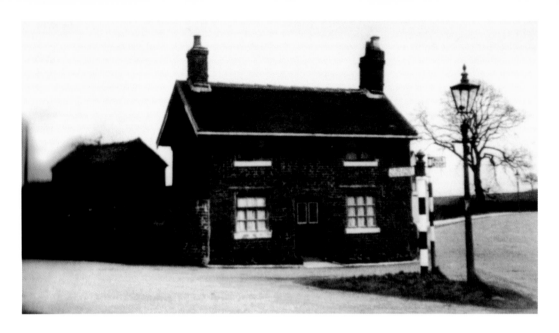

Deans Lane Toll-House

At the other end of Deans Lane, a toll-house still stands at the junction with Audley Road. Tolls were collected here 'for traffic leaving the "North Road" [the Tittensor–Talke turnpike] as well as traffic from Chesterton via the then un-turnpiked Audley Road' (D. Dyble). As the modern picture shows, the toll-house remains, now a private dwelling.

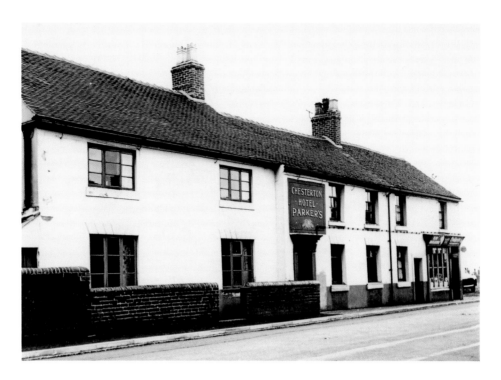

Chesterton Hotel/Goods Yard, Audley Road

The residential area along Audley Road, shown in the present-day photograph, was the site of this quite impressive inn. More surprisingly perhaps, the site of the railway goods yard lay behind these residences in what is now Sunningdale Grove. The Chesterton branch line, part of the North Staffordshire Railway system, was for freight only. It was opened in 1886, with the track finally lifted in 1920. It was used by local collieries, one of which was in the nearby Water Hayes Valley. However, much of the freight consisted of bricks and tiles made in this area.

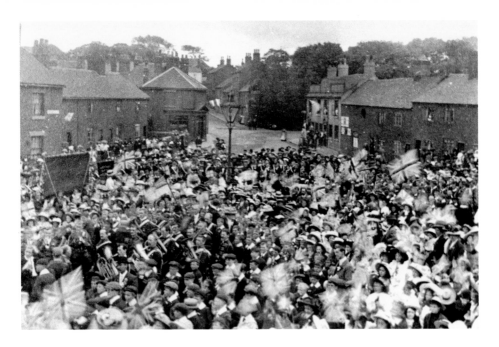

Red Lion Square

A turning from the bottom of Audley Road takes the traveller back into the village. Red Lion Square was the original village centre and the Red Lion is its oldest public house, dating from about 1750. The Square was the scene of village celebrations. In the old photograph the event for celebration was the coronation of Edward VII in 1911. The more enclosed appearance of the old square has disappeared with new residential developments.

Holy Trinity Church, 1851–52

Chesterton was in the parish of Wolstanton until 1846, and Anglicans worshipped there at St Margaret's. Then the parish of Chesterton was set up, a reflection of the growth of population in the area. The land for a new church was given by Ralph Sneyd of Keele Hall. Other support came from the Heathcotes of Apedale Hall, Francis Stanier senior and Thomas Kinnersley, who owned the New Hall in Chesterton. These were the families most involved in the industrial growth of Chesterton, Apedale, Knutton and Silverdale in the mid-nineteenth century and the ones who supported the building of churches in all three villages. Holy Trinity seated 485 people and was built of local sandstone with a high steeple at a cost of about £2,000.

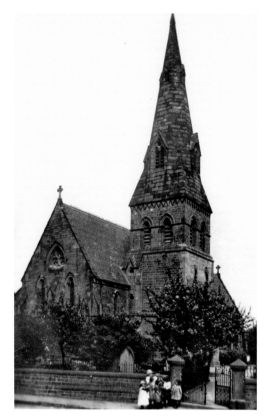

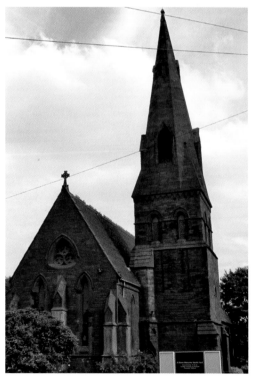

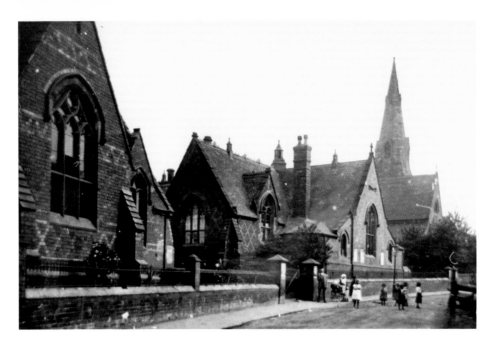

The National School

The old photograph shows Chesterton National School, built 1847. National schools were set up by the Church of England to provide education in an age when there was no state system of education. Nonconformist churches did the same. With population on the increase, however, more schools were needed and the Board Schools, like those in Albert Street, were built. The National School continued, and in 1931 became Chesterton County Primary School. The buildings were eventually demolished as the new photograph shows.

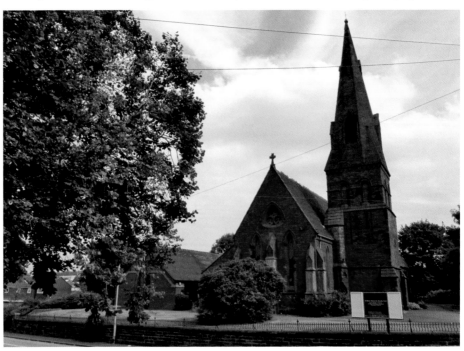

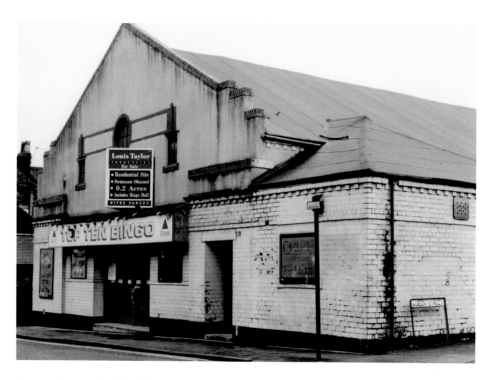

Entertainment in Victoria Street

The new picture shows some recently built houses. These have replaced the building in the older photograph. There is no doubt what it was used for then – but before turning to Bingo, the building had been used as a cinema, as its architecture suggests. This was the Victoria Cinema.

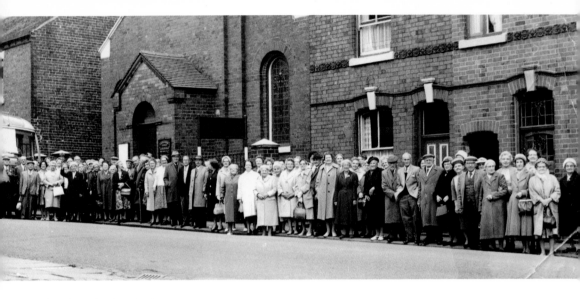

The Chapel, Victoria Street

Built as a Baptist chapel, this building, between two blocks of terraced housing, became a Congregational chapel in 1896 (now United Reform). Its most charismatic pastor was Charles Nicholls, who later was elected as Liberal MP in Northampton in the 1906 election. 'When he returned to Chesterton his carriage was dragged through the flag-bedecked streets. Outside the chapel, a huge streamer was suspended across Victoria Street, bearing the words "Welcome to our own MP"' (D. Dyble). The terraced housing in Victoria Street retains much of its original appearance (c. 1880s). With the population growing in the 1870s and 1880s, there was a need for new housing. Victoria Street and Albert Street were built and were to be connected by King Street and Queen Street – there is no doubt from these names of the period of this development! King and Queen Streets were never completed.

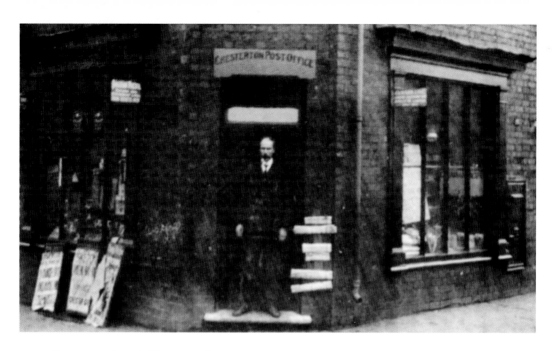

Chesterton Post Office, Victoria Street, *c.* 1914

Situated on the corner of King Street and Victoria Street, the early twentieth-century post office stands opposite its modern counterpart. As well as handling postal business, the post office clearly also sold newspapers and served as an office for the Canadian Pacific Shipping Company and the Cunard shipping line. These advertisements show that emigration to North America was now regarded as an escape route in hard times.

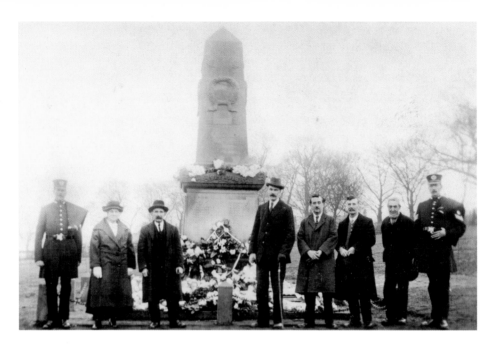

War Memorial, Chesterton Park

The War Memorial stands in Chesterton Park, just inside from the King Street entrance. The old picture shows the dedication ceremony on 10 November 1923. It had taken five years to raise the money for the sandstone obelisk, raised in memory of the 138 men who had lost their lives in the First World War. The memorial was unveiled by Sir Joseph Cook, High Commissioner for Australia. His life will be described when the journey in this book reaches Silverdale.

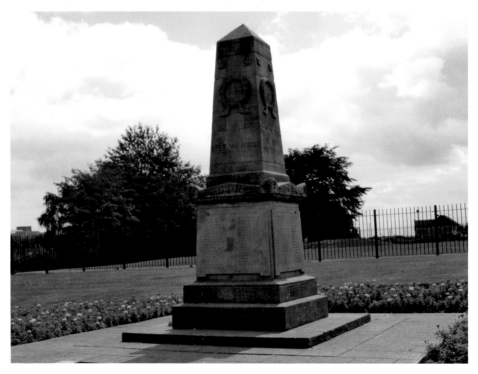

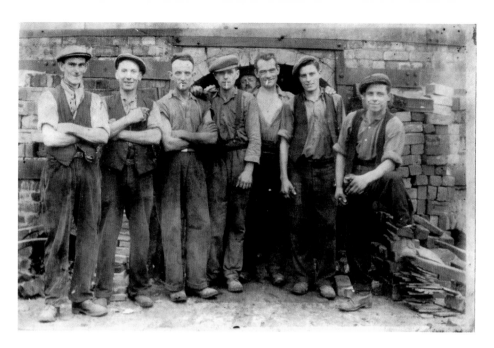

Brickworks, Audley Road

Opposite the goods yard site is a large, modern brickworks. The original works here were set up by Downings, a large-scale producer of bricks and tiles in Chesterton, Knutton and elsewhere in the area. Brick and tile making was one of the major industries in North Staffordshire, along with coal and iron. There were nine brick and tile works in the Chesterton area alone. This is the only survivor. The old photograph shows workers at another branch of Downings, this one in Church Lane in Knutton. They would have been working the old coal-fired beehive kilns.

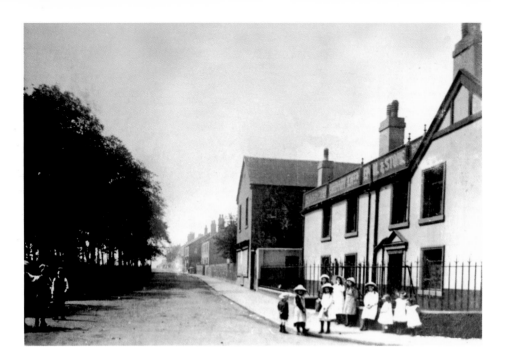

Apedale Road

A right turning at the bottom of Audley Road leads to the valley of Apedale. The Eagle and Child remains on the corner, outliving many of the inns in the area. It is listed in an 1854 trade directory. There is a pleasant, rural appearance depicted in the old photograph, not so evident in the motor age. However, even in the second half of the nineteenth century, there was considerable development along Apedale Road. Three roads of terraced housing were built to accommodate mainly miners and their families, as industrial development grew in Apedale. All three have now disappeared, leaving a mixture of housing and industrial sites on the way down into the valley.

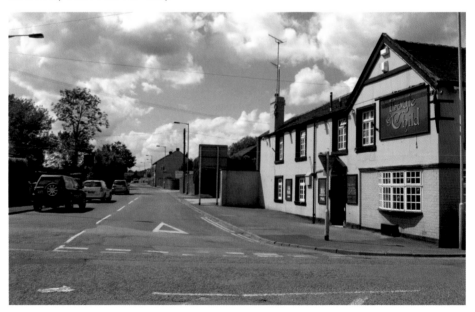

Apedale

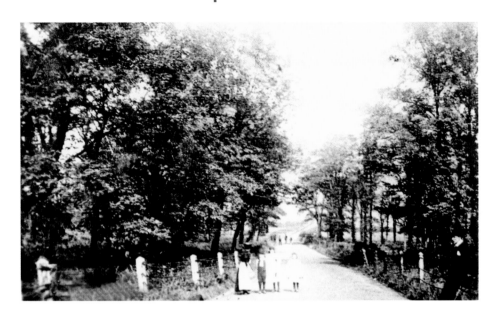

Entering Apedale Valley

In the old photograph, the children walk in the Apedale Valley, along Apedale Road. The road into Apedale still affords attractive views of the valley, as the modern picture shows. The fine countryside of the Apedale Country Park lies ahead. It is difficult to imagine the view 150 years before, when the coal mines, ironworks, brickworks and other industries filled the valley with noise and smoke.

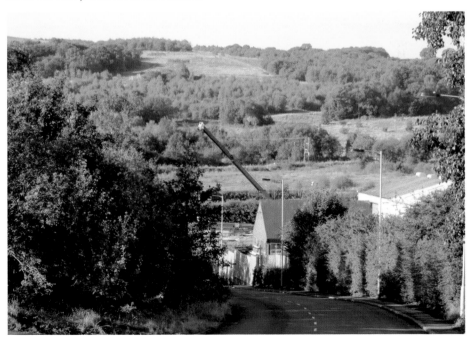

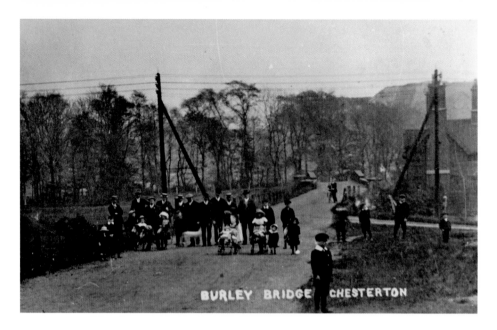

BURLEY BRIDGE CHESTERTON

A Walk in Apedale

The old photograph shows a popular walking route down to the Apedale Valley where Burley Bridge crossed the Gresley Canal. The walkers are pictured with Burley Bridge behind them as they walk in the direction of Watermills. The bridge has now gone, buried under the rough roadway at the bottom of Apedale Road. This area serves as one the entrances to the Apedale Country Park. The road from here climbs steeply towards Watermills. The more recent picture shows what must have been one of the last views of Burley Bridge, taken in 1986, when it was a sad remnant of its former self.

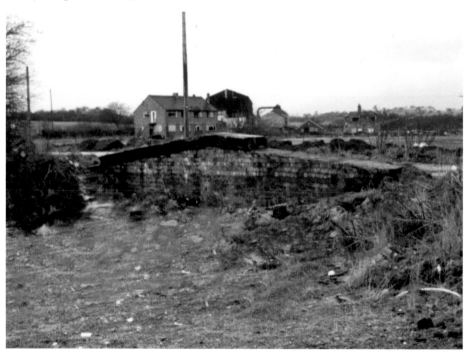

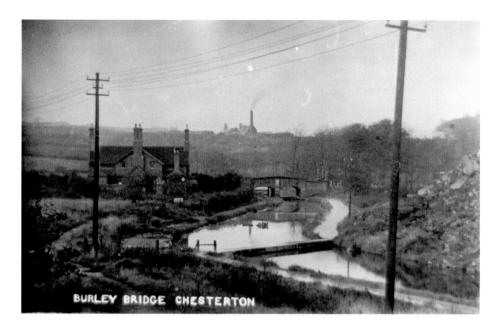

BURLEY BRIDGE CHESTERTON

Burley Bridge and the Gresley Canal

The old picture shows Burley Bridge in the centre, with the Gresley Canal passing under it. The canal was constructed in 1775–76, promoted by Sir Nigel Gresley, a prominent landowner in Apedale and Chesterton. Its main purpose was to carry coal, mined on Gresley land, to nearby Newcastle-under-Lyme. It was a contour canal, 3.5 miles long. The canal was never connected to the main canal network then developing in the Potteries area, but it seems to have been successful. Eventually, it was overtaken by the railway. The canal has virtually disappeared, with only vestiges remaining and often in inaccessible places. The new photograph shows one of those vestiges – a section of the bed of the canal and some brickwork.

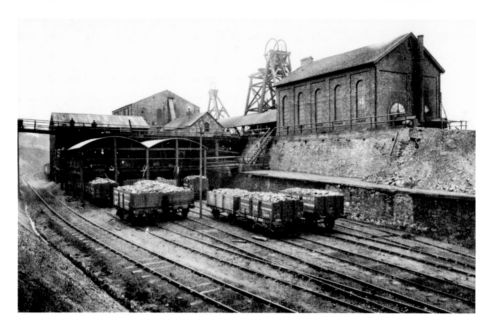

Burley Pit, Apedale

Burley Pit, shown in a old photograph, was one of the most productive coal mines in the country. It was also among the deepest; a visitor in 1833 was astounded at a the depth at Burley: 'The perpendicular depth was 720 feet. At the bottom of this was a steam engine drawing up coals from 1,800 feet deeper.' The pit continued in production until the 1920s. The photograph shows the busy pithead scene, with the headsticks, the engine house, the railway lines and trucks. This pleasant, wooded scene in the present day, part of the Apedale Country Park, marks part of the location of the pit. There are a number of attractive pools in these woods, the water a necessity for the steam engines.

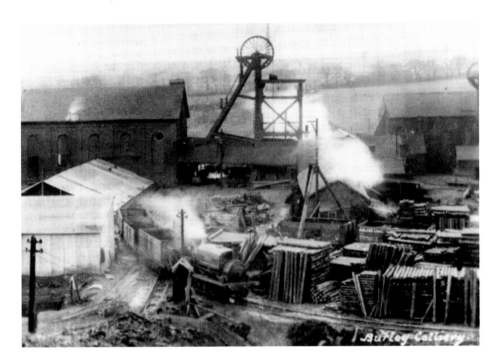

Burley Pit and Watermills

Walkers in the park are often surprised and puzzled to come across this structure. It is in fact the base of the much higher ventilation chimney of Watermills Pit. A further puzzle is presented by the words on the four plaques at the top of the tower – 'Live and let live', 'Be Just and fear not', 'Regard the end', 'REH AD 1840'. The clue is in the initials at the end; the initials of Richard Edensor Heathcote, the landowner whose estates included Apedale. What he intended to convey is less clear. In the old picture of Burley Pit in 1805, it is possible to see the original 186-foot chimney in the centre background.

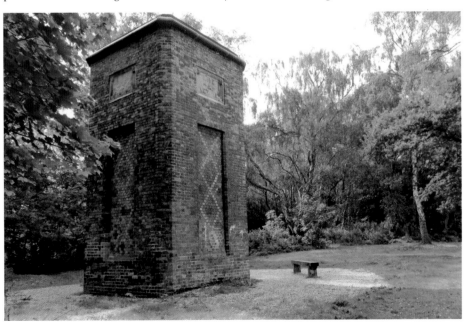

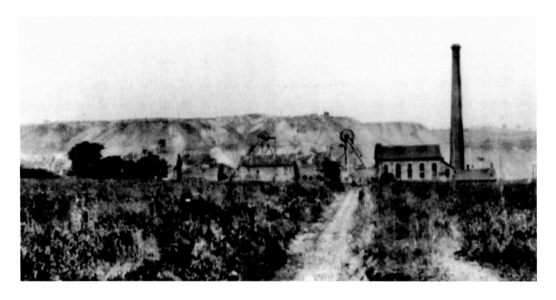

The Tramway Burley to Watermills
The old picture shows the path of the tramway along which coal from Watermills was hauled for screening at Burley. It was worked by steam haulage, indicated by the chimney and engine house on the right. There are also traces of another tramway from Watermills in the woods leading down to the present Heritage Centre area. The new photograph looks across the fields from near the Watermills site towards the site of Burley Pit. The hedge line in the distance could have been the tramway. Above the woods where Burley was situated can be seen some cottages that indicate the site of the Springwood Iron Furnace.

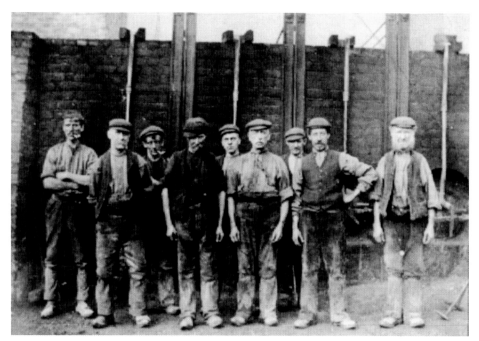

Burley Miners

Among the collection of mining equipment at the Apedale Heritage Centre are these pit cages. The old photograph shows a group of miners at the Burley Pit, one of the deep pits that would use cages to descend the deep shafts. One horrific accident at the Watermills Pit involved a cage overshooting the top, spilling out the miners, two of whom died. This bizarre event is a reminder of the dangers faced in the pits. There were accidents and deaths recorded. This is a sample: a single miner was killed on a tramway from Watermills, 1874; twenty-three died in an explosion at Burley, 1878; ten died in a explosion at Sladderhill Pit, adjacent to Burley, 1884.

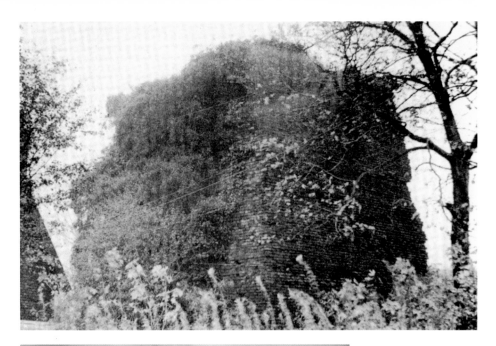

Springwood Furnace
As the new photograph shows, the Springwood Furnace, from 1790, has survived the years in very good condition and is now more visible. It stands in the garden of a private house, a protected site under English Heritage. It was a speculative venture backed by a local industrialist, Thomas Kinnersley, who had built a hall in Chesterton. It was a coke-fired iron furnace, using steam power to drive the machinery. It only operated for about ten years, perhaps because it was in a remote spot, high on the hill, and materials had to be hauled up from the valley.

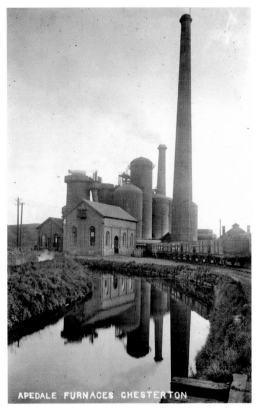

APEDALE FURNACES CHESTERTON

Apedale Ironworks, 1930

The Apedale Ironworks was a large-scale operation. Francis Stanier had extended his business interests by taking over the ironworks and mines of the Apedale Valley in the 1860s, adding them to his mines and ironworks in Knutton and Silverdale. Rail links via the Apedale Branch line meant quicker access to and from the valley. The old picture shows the Apedale Ironworks in 1930, by which time the whole complex was up for sale. The new picture gives a view across the central part of the Apedale Heritage Centre, which was the site of some of this large ironworks.

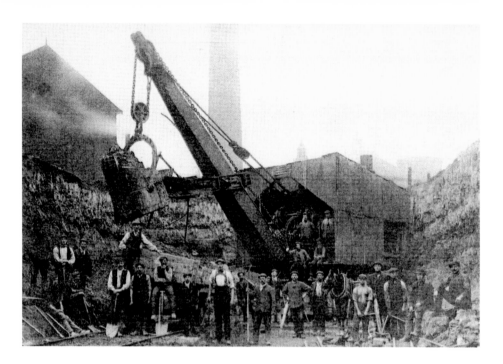

Apedale Ironworks, Demolition

After Stanier's era, his interests were taken over in 1890 by the Midland Coal, Coke and Iron Company, in which the Heathcotes played a major role. By 1900, it is estimated that over 3,000 men worked in the valley. Later, however, these industries suffered a serious decline in the bad economic times of the 1920s and 1930s and the company went bankrupt. The whole of the plant and equipment of the ironworks was auctioned. The old photograph shows the demolition of the ironworks. The recent picture looks across to the workshops, now used by the Moseley Railway Trust. This area was also once part of the ironworks. One of the brick buildings, it is thought, might have survived from that time.

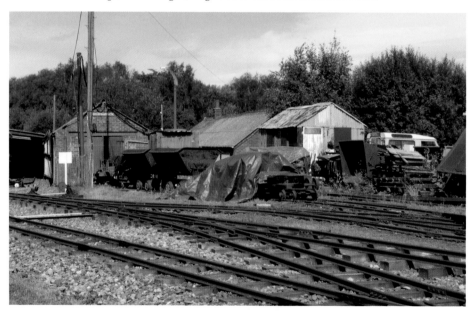

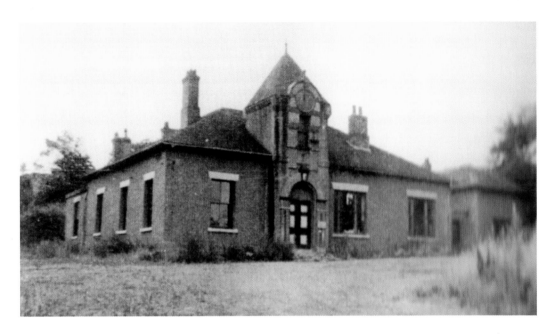

Midland Coal, Coke and Iron Company Offices

The offices in the new photograph are still in use. They served as offices for the Crouch Mining Company, which was responsible for the opencast mining operations in Apedale which started in 1987. The old picture shows the offices of the Midland Coal, Coke and Iron Company. These smart offices, with a clock tower and mahogany counter, were situated in the wooded area in the new photograph, behind the present car park. The ladies from the office are pictured in the inset.

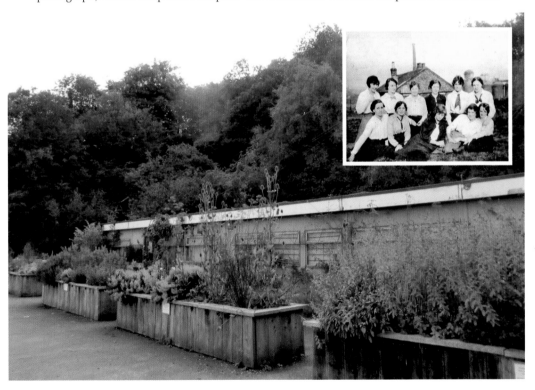

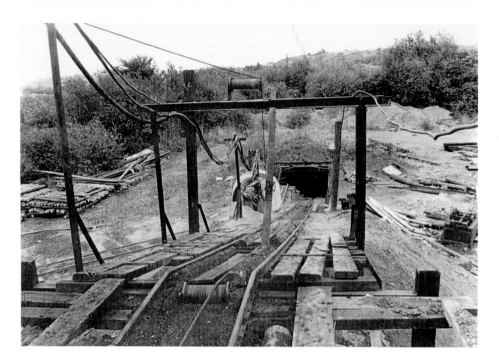

Footrails

The old photograph shows the entry to a mine, with the rails used for hauling out the coal. The mine is a footrail (the usual name in the area) or drift mine. In a footrail, the coalface is reached by means of an incline rather than a vertical shaft. It was a common method of extracting coal in Apedale. The new photograph shows the entrance to a new footrail on the Apedale Heritage site. The rails used for haulage are narrow 2-foot gauge, operated not by locomotives but by cable. Earlier methods of haulage might have involved horses or steam engines.

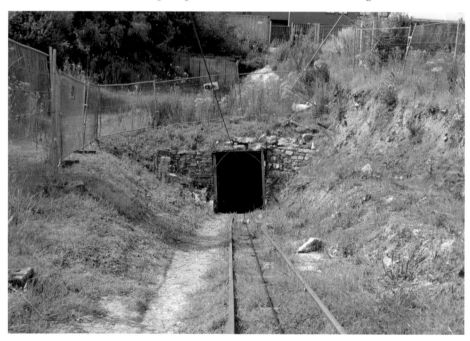

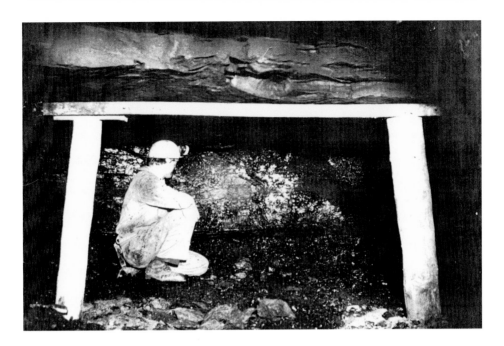

The Apedale Mine

Apedale Colliery had substantial history before it was reopened by the National Coal Board in 1948. The mine employed between 100 and 140 men and broke a number of records in production. Later privately owned, it finally closed as a commercial venture in 1998. Now, run by the Apedale Heritage Centre, parts of the mine have been reopened for guided tours. The old picture shows a miner at work in a footrail. In the new picture, two satisfied customers emerge from a guided tour.

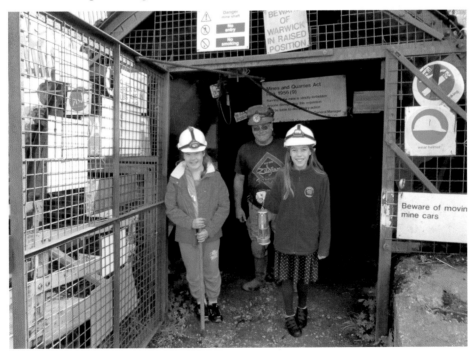

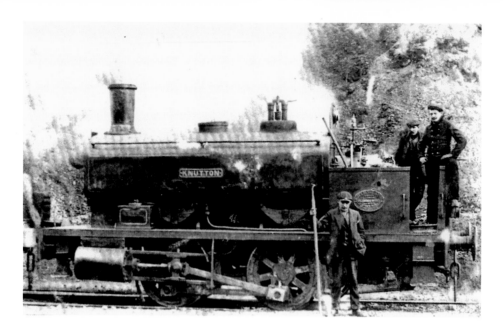

The Locomotives

Many of the old photographs show the importance of the railways in the industries of the valley. Now, in the new picture, the railways play a different role. Trips for visitors are run by the Moseley Railway Trust. Here a narrow gauge locomotive is used. This one, works No. 3014, was built in Stoke-on-Trent to order for the French government in 1916. Its job was to ferry supplies to the trenches. Later it was used in quarry work near Calais. Eventually returned to England, it was restored by the Trust. The old photograph shows *Knutton*. Built in Scotland for Knutton Forge in 1900, it is a fine example of the type of locomotive used in the industries of the area.

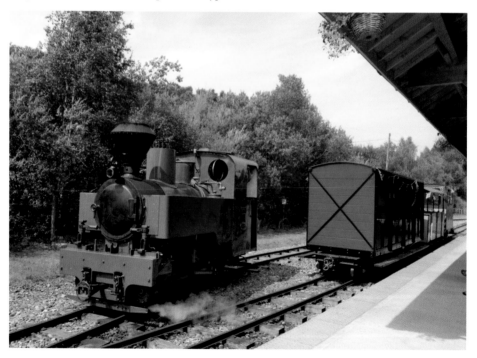

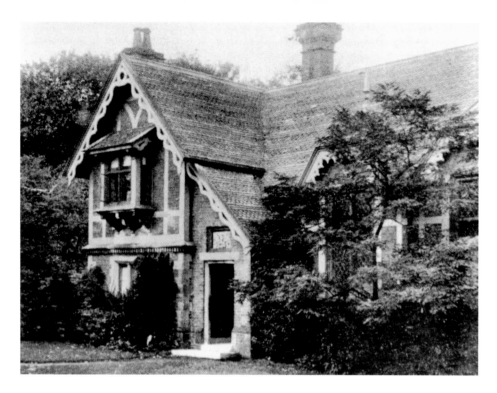

Heathcote Estate School

John Edensor Heathcote (1810–69) set up a school for the workers on his Apedale estate. A first, temporary site for the school was an old engine house in the Springwood area. In 1857, however, he had a new school built specially for the task. The school building still stands, at the top of the steep Apedale Road. Now a private house, it is shown in the new picture. An earlier school was founded by him at neighbouring Alsagers Bank.

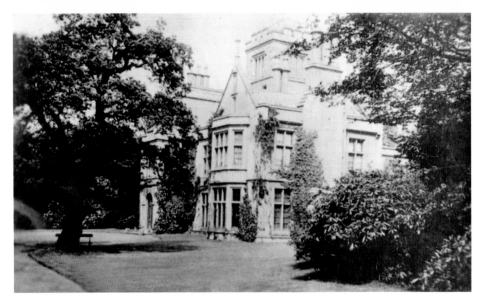

Apedale Hall

Apedale Hall, the impressive residence of the Heathcote family, was built in 1826. It was situated on the Apedale Road, high above the family's lands in Apedale. The new picture shows a stained glass panel with the family's crest. This is now displayed in the Richard Heathcote School just along the road in Alsagers Bank. The Hall was put up for sale in 1930 after the collapse of the family's fortunes but no buyer was found and in 1934 it was demolished.

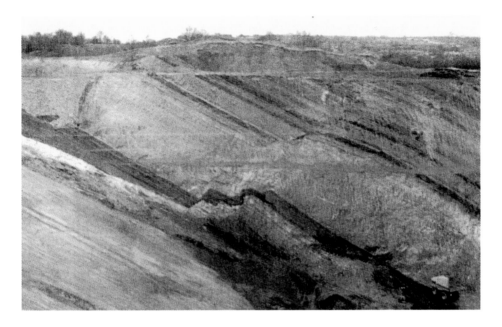

Opencast and the Void

In 1976 it was officially recognised that the Apedale Valley had become 'an area of extreme dereliction'. No action was taken and in 1987 a decision was made to opencast the area. A massive operation followed and the effects on the landscape were immense. The older picture shows the landscape created by the operation which ended in 1994. One of the results of the movement of huge amounts of earth is seen in the new photograph. This is the Void, a huge area hollowed out of the hill. The view shows, beyond the large pool, the estate being built over the Silverdale Colliery site and, to the right, the Enterprise Park built over the old furnace site. After all this activity came the creation of Apedale and Silverdale Country Parks.

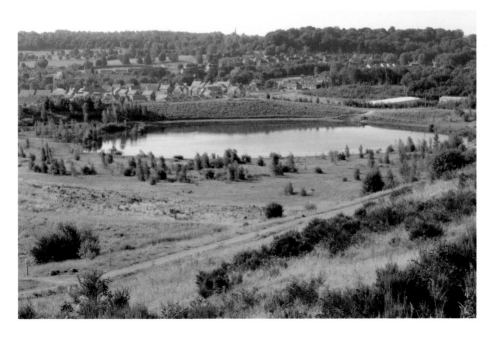

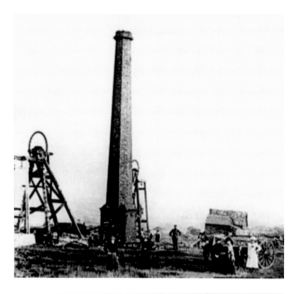

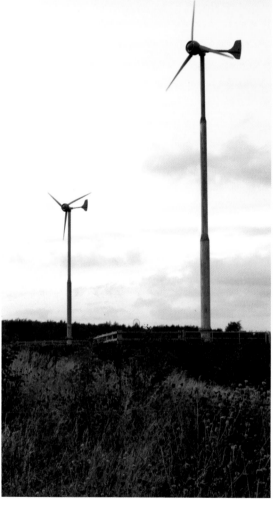

White Barn Collliery and Wind Power
From High Lane and the Void,
Blackbank takes the traveller to
Knutton. On the way, an area known
historically as White Barn is passed.
This was the site of White Barn
Colliery, shown around the time of
its demolition. A note appended to
the picture states that the colliery,
founded in 1800 by the Lawton
family, was demolished in 1902. An
interesting comparison can be made
with the current use of the site – an
energy centre accompanied by two
wind turbines.

Knutton

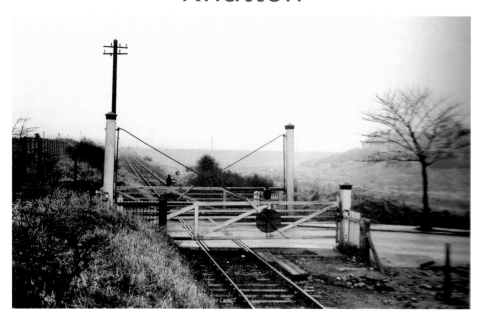

The Apedale Branch Line

The important rail link between Apedale and the line from Newcastle to Silverdale and later Market Drayton was made at Apedale Junction near Knutton. It crossed Milehouse Lane on its way to Apedale at the crossing gates shown in the old picture. The modern photograph shows the site of the crossing. Only walkways mark the lines of the railway nowadays.

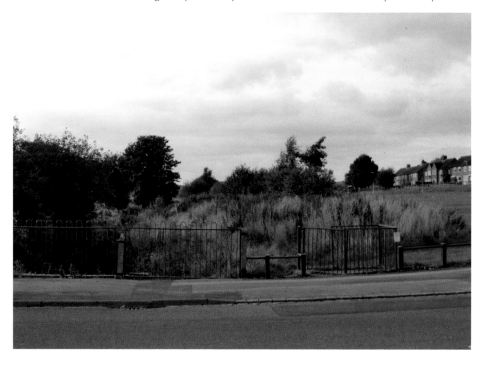

High Street, Knutton

The old photograph, taken around 1925, shows Knutton High Street, with the corner of Nash Street to the right. The present-day scene is not much different on the right of the picture, apart from the extension to the shop. The scene on the left, however, has changed considerably. The old picture shows fences, houses and trees. Now it is a collection of old school buildings, a miners' school and community buildings.

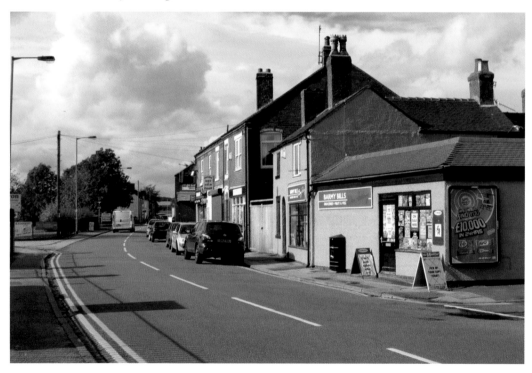

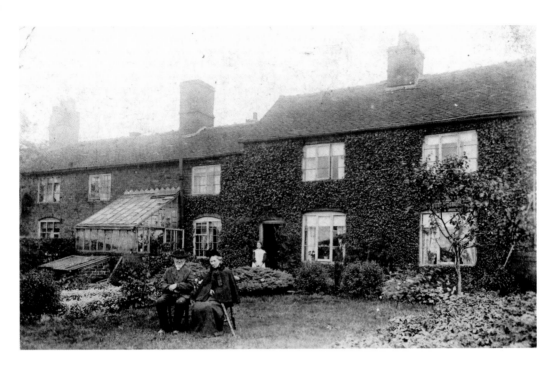

The Clusters, High Street, Knutton
These houses faced towards Silverdale, with their back gardens on the High Street. Judging by the costume of the couple sitting in their garden, this picture was taken either early in the twentieth century or before. The scene here has now changed completely. The houses have gone along this stretch of the High Street and here have been replaced by a recreation centre.

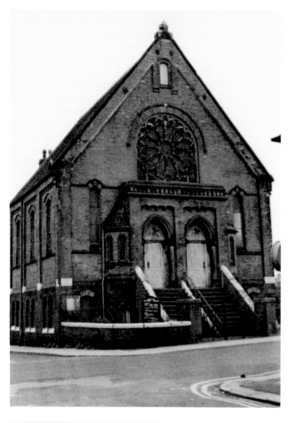

Methodist Chapels, High Street

The recent picture shows the modern Methodist chapel, built in 1980 but since closed, leaving Knutton with no working Methodist chapel. Historically, however, the village had four chapels: the Wesleyan at the site of the modern chapel, an earlier chapel in Cemetery (formally Paradise!) Street, a Primitive chapel, and a United Free Church chapel in the High Street. Predating these was a chapel at White Barn on Blackbank. None of these survive. A collection of memories of people in the village stresses the very active part Methodism played in their lives. The old picture shows the Wesleyan chapel.

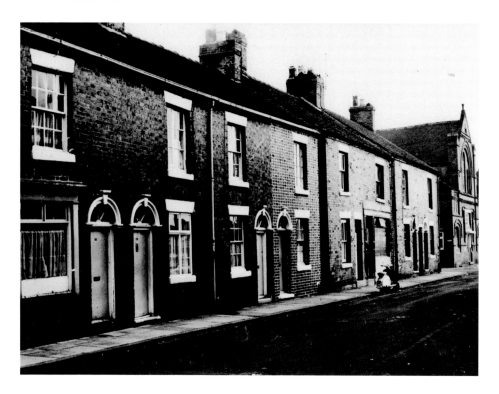

High Street – Another View

The old picture shows both the terraced housing along the street and the Primitive Methodist chapel of 1876, now demolished. The new photograph shows the changed appearance of the High Street. The gap left by that demolition is marked by the trees and the grassy area between Gordon Street and Chapel Street. Behind that grassy area are bungalows for the elderly, known as Gordon Court.

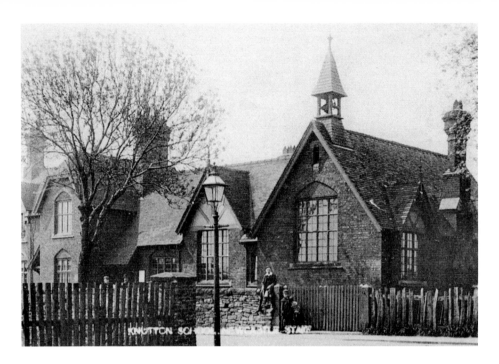

The National School

In all three villages described in this book, the increase of population in the second half of the nineteenth century led to the founding of schools, especially by the Church and the chapels. This led to the foundation of national schools in each of the villages. Knutton National School was opened in 1874 in the buildings shown here – buildings which have survived well. Land and money for the school was provided by the Sneyds, the Staniers and W. F. Gordon. Gordon, 'coal master, brickmaster and ironmaster', had founded an earlier school in the village. The national school was a mixed school 'for the education of children of the labouring, manufacturing and other poorer classes of the Township of Knutton'. A house was provided for the headteacher, shown on the left of the school buildings.

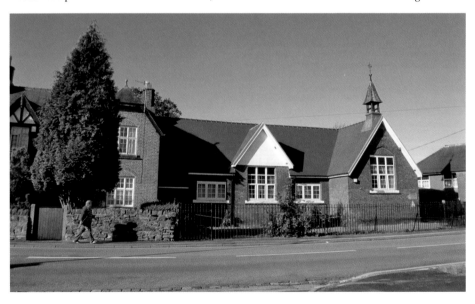

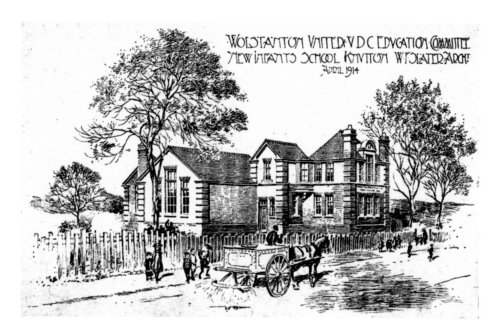

The School Expands

The school had to be expanded on a number of occasions because of overcrowding. Knutton was in the Wolstanton Urban District Council area until 1932. It was Wolstanton School Board which built a new infant school on the site adjoining the national school site. The old photograph shows a draft of the buildings planned. The new picture shows the actual building as it is today. A new school, situated in Church Lane and not far from its original site, serves all age groups.

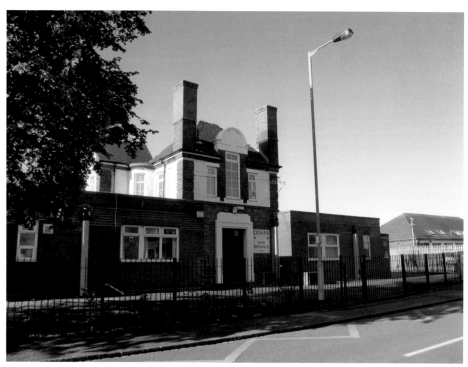

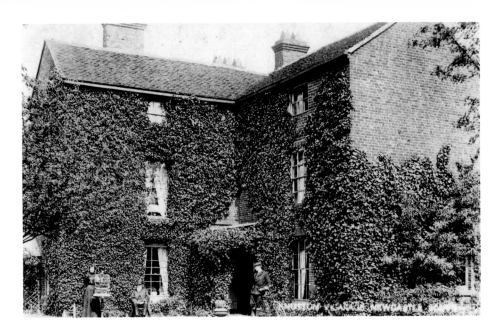

Vicarages, Old and New

The old photograph shows the first vicarage. This large Victorian building, known as Knutton House, remained the home of successive vicars from 1874 to 1957. By that time, the house was suffering from subsidence and was not thought to be worth repair. So, in 1957 a new vicarage was built and is shown in the recent photograph. For a period of forty-seven years between 1877 and 1924, the old vicarage was occupied by two vicars, father and son. The father, Revd Ezra Thompstone, was the vicar for forty-one of those forty-seven years.

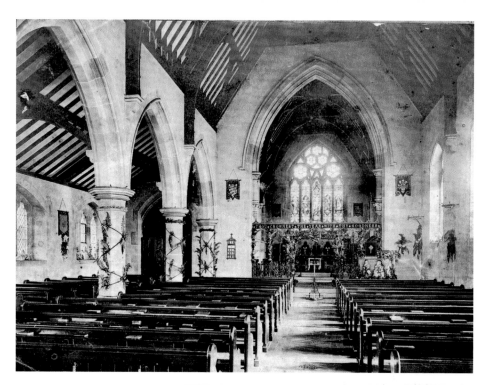

St Mary's Church, Knutton
St Mary's church (1872–74) was built slightly later than the churches of Chesterton and Silverdale. It shared with those churches the patronage of the same local families, the Sneyds and the Staniers. The first vicar, Revd Steele, served for only two years before the long tenure of the two Thompstones. The interior of the church has changed, as these two photographs show. The wooden screen at the chancel has gone and the north aisle has been partitioned off to serve different functions in the work of the church. The exterior keeps its solid Victorian appearance.

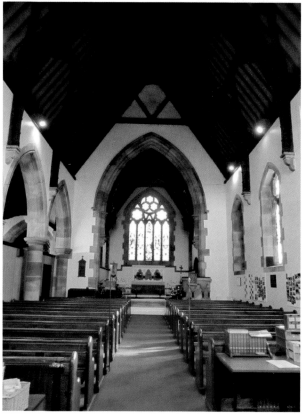

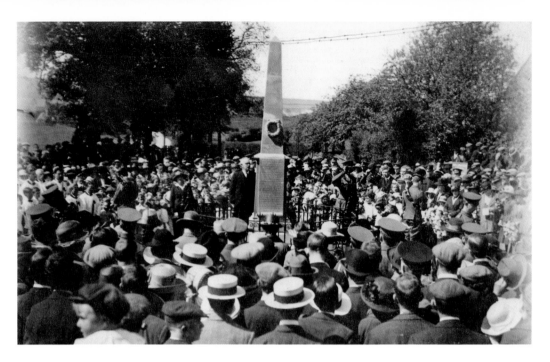

The War Memorial

The old picture shows the dedication of the War Memorial in the 1920s. With the advent of modern traffic, the memorial has had to be moved into its present position at the side of a very busy pair of roundabouts.

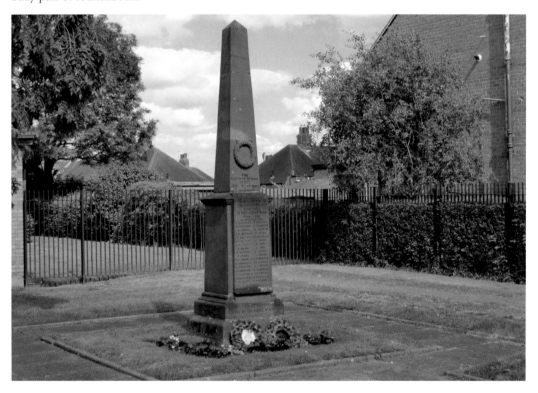

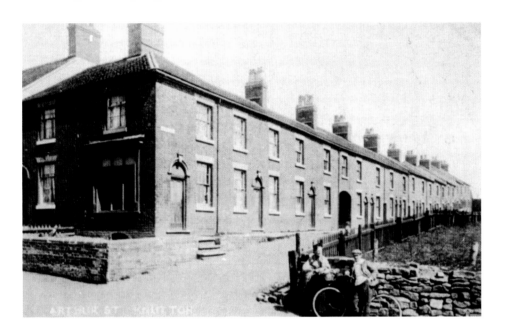

Arthur Street, Knutton

This old photograph was taken around 1914. It shows a block of miners' houses on the left of Arthur Street. The entryway, shown in the middle of the terrace, served as a passage to the backs of the properties. The right-hand side of the road remains undeveloped. The modern picture stands in complete contrast, with modern housing on both sides of the road. Only the name of the street remains the same.

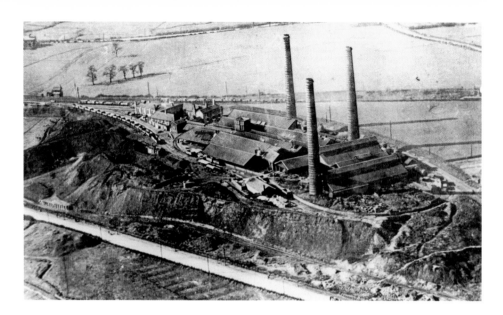

Knutton Forge

The huge site of Knutton Forge, which covered a wide area between Knutton Lane, Church Lane and Silverdale Road, is now occupied by a mixture of housing, a ceramics manufacturer and a walkway following the old railway track. The forge was built by Francis Stanier as part of his large industrial empire in the middle of the nineteenth century. This photograph from around 1900, a remarkable aerial view, shows the three big chimneys that became a landmark. The steady thump of the 38-ton steam hammer was another well-remembered local feature. The site was a complex of furnaces and mills, producing large quantities of iron in its heyday. The railway from Silverdale to Newcastle runs across the top of the picture behind the chimneys. The road to Newcastle runs from the left at the bottom of the picture. The modern picture, showing some of the redevelopment of the site, is taken from that road. The forge closed in 1929 as the economic situation deteriorated.

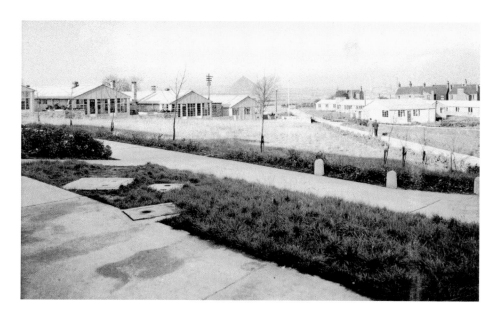

The Miners' Hostel

Just past the Methodist chapel, there is a turning into Malham Road and a modern housing development, shown in the modern picture. During the wartime period this area was the site of the Miners' Hostel (opened in 1944). The old photograph shows some of the buildings that housed the miners. They were brought into the area to work in the coal mines as part of the war effort and the recovery effort afterwards. Some came from Europe, some from other parts of the country. In answering a question about the hostel in Parliament from the local MP, the minister responsible, Major Lloyd George, gave some facts about the hostel; its cost was £95,000 and in February 1945 it housed 330 miners. This influx of men from such a wide variety of areas is still remembered by older members of the community.

The Prefabs

A large number of prefabs were built on the land off Church Lane. An aerial photograph of the time shows these 'temporary' houses covering a wide area. They remained for longer than first intended but eventually were replaced. The modern picture shows part of the more permanent development in Acacia Avenue.

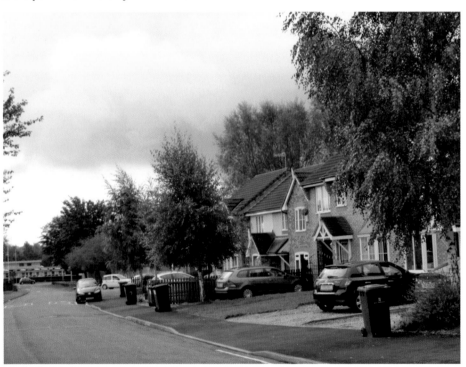

Silverdale

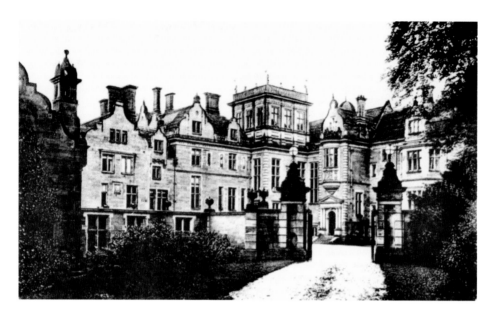

Keele Hall & View from Keele

Ralph Sneyd (1793–1870), who built Keele Hall (completed in 1861), owned much of the land in Silverdale and Knutton. The impressive house reflected his considerable wealth gained from exploiting the mineral resources of the area. Families like the Sneyds and the Heathcotes of Apedale built substantial properties overlooking the lands they owned – but far enough away to avoid the smoke and noise. The new photograph shows the present-day view from Keele Bank. Now the pitheads, iron furnaces and railways that Sneyd would have surveyed have all gone. Still just visible on the right of the new picture is the end of a very large marl hole, behind what was once a brickyard.

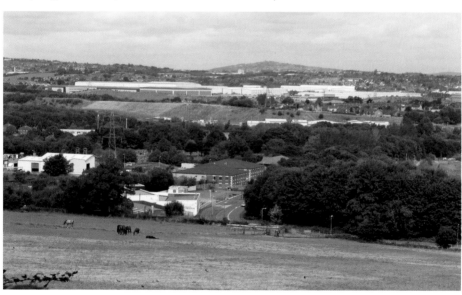

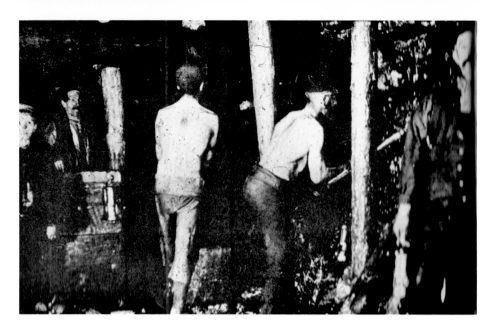

The Mining Memorial

The impressive Mining Memorial is placed at the entry to Silverdale, where the two main streets of the village meet. A great deal of information on the part played by coal mining in the village is displayed on the memorial, along with tributes to the miners. On one side are displayed four plaques to four memorable Silverdale people: Joseph Cook, John Cadman, Fanny Deakin and Harold Brown. It was Harold Brown who wrote so vividly and movingly of the miners he had worked and lived with in a book entitled *Most Splendid of Men* (1981). The old photograph does a little to reflect the conditions under which those men worked.

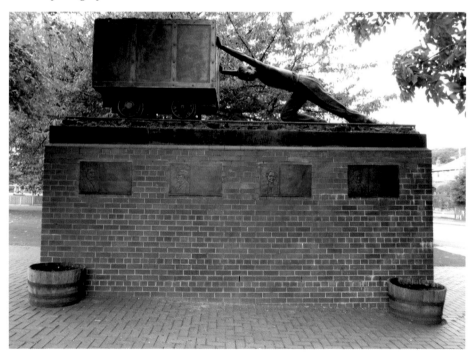

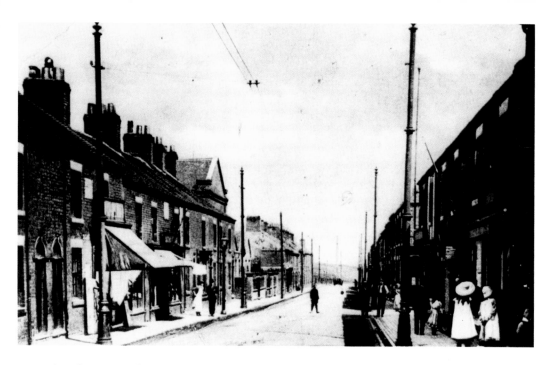

Church Street, Silverdale

The old view of Church Street was taken in about 1910 in the direction of the Mining Memorial. Faintly visible in the centre are the chimneys of Knutton Forge. Terraced housing on the right has survived but the shops have mostly gone. In the new photograph, the trees indicate an area where much building has disappeared to make way for a park and playground.

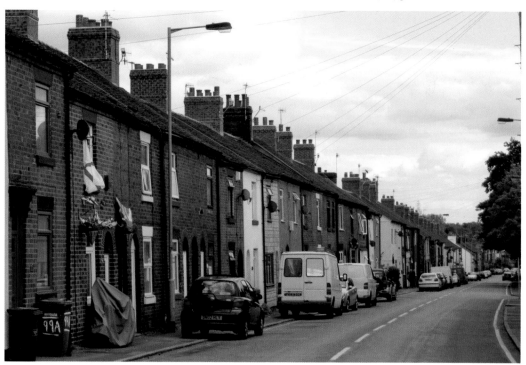

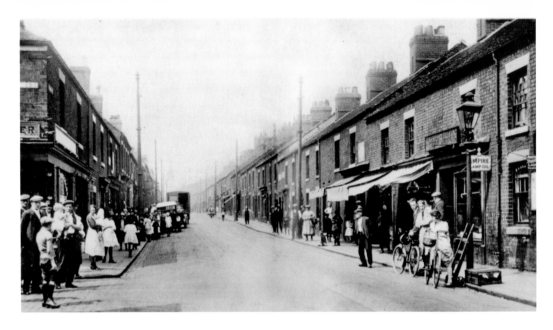

Church Street Towards the Church

This reverses the previous view of Church Street and the new photograph shows the changed appearance of the street on the left. The park area behind the trees creates an opening through to a parade of shops and onto the parallel High Street. Both photographs were taken with Crown Street on the left, the old one in 1925. The atmosphere of a busy shopping street in the earlier picture has disappeared in the recent one, though most of the buildings on the right seem to have survived.

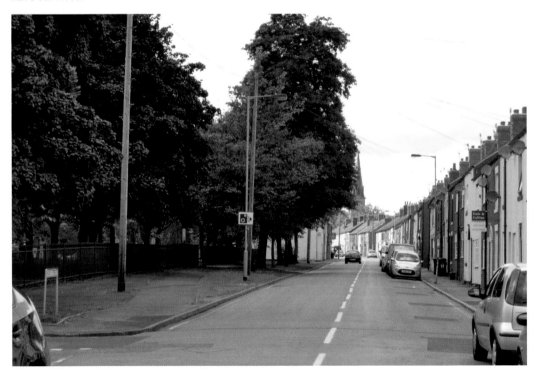

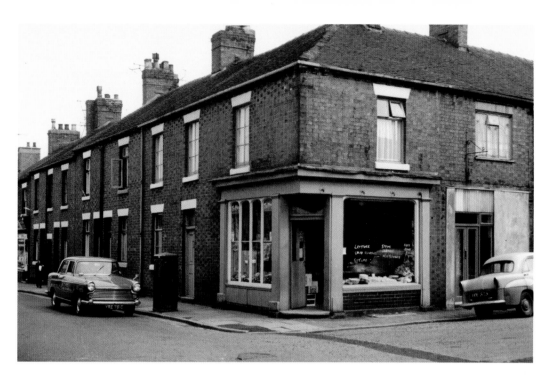

A Shop Remembered, Newcastle Street

The shop is shown in the older photograph in the 1960s. Now it is a dental surgery. It is remembered by its former resident: 'We moved there in 1959, taking over an already existing greengrocers until 1973. It was sold to a dentist in 1983. Originally the building was a public house, probably a beerhouse. It had a traditional North Staffs pub layout – the front door opened onto a long corridor with small rooms off each side. The stairs wound round at 180 degrees.' This memory gives some context to the changing uses of a building through time.

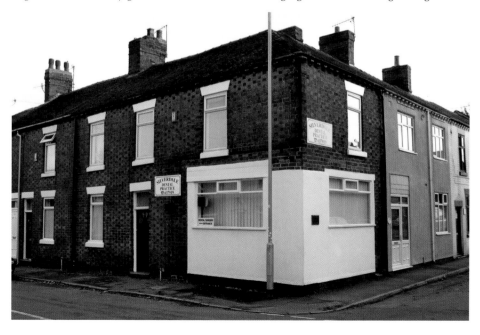

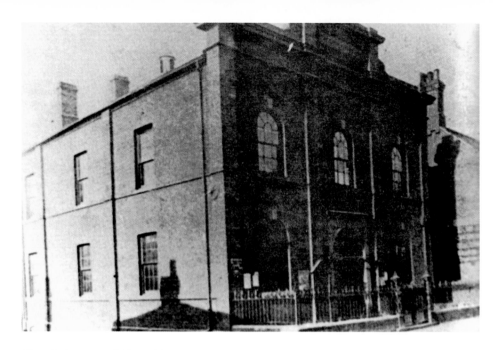

Church Street and Chapel Street

The strength of Methodism in all the villages described in this book was reflected in the number and, in many cases, the size of the chapels in each village. There were the customary rivalries between the different strands of Methodism. There were four Methodist chapels in Silverdale, but now there is only one, in new premises in Earl Street. The Bethel Methodist chapel (1856), on the corner of Chapel Street and Church Street, is shown in the old photograph. It was a large red-brick building which had replaced an earlier Bethel chapel of 1834. The site on this corner remains unfilled.

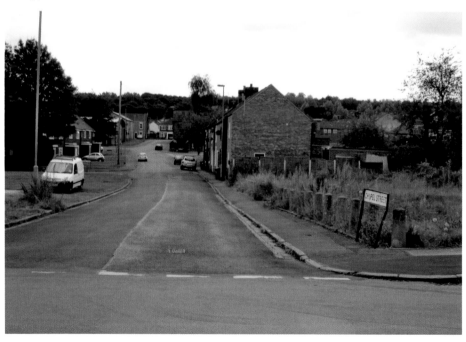

The Gothics

The picturesque group of old stone cottages was built in the early 1850s. They were situated just below the parish church on Church Street. They were demolished in 1960 and replaced by the houses in the new photograph. These cottages have a special claim to fame: they featured as a setting in the 1939 film *The Proud Valley*, starring Paul Robeson. The film also used miners as extras and Kent's Lane Colliery as a setting.

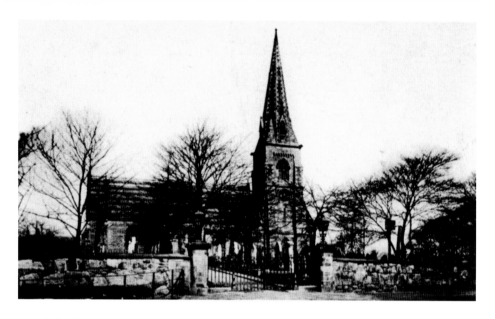

St Luke's Church, 1853

St Luke's church, like the parish churches of Knutton and Chesterton, was built in the Victorian period. The Church of England was trying to provide for the increasing population in areas like North Staffordshire. Another common feature of the three churches was the financial support given to their building by local landowners and industrialists. In the case of Silverdale, this support came from Ralph Sneyd of Keele Hall and Francis Stanier. The solid-looking structure that has survived in fact faced demolition in the 1980s. Major repairs were required to the tower in particular. Local action saved the church by raising the money for repairs.

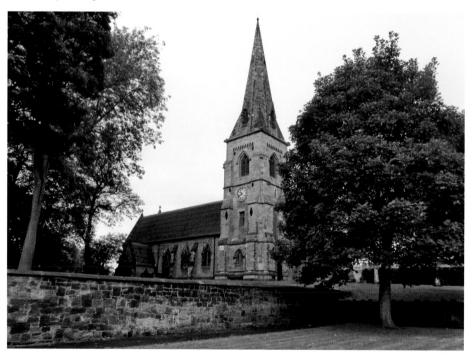

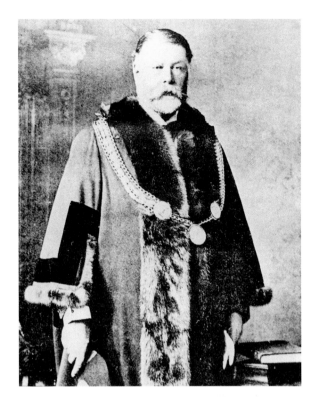

The Stanier Memorial Plaque

In the chancel of St Luke's is a memorial to Francis Stanier. A Newcastle-under-Lyme solicitor, Stanier became a partner of Ralph Sneyd in the Silverdale coal and ironworks and in 1851 bought out Sneyd's share. He died in 1856 and his agents and workers raised the money for the memorial in appreciation of all he had done for the area. His son, also Francis, is pictured here. He expanded the business of Stanier & Co. to include the coal mines in Silverdale and Apedale, the ironworks in both places and the forge in Knutton. He purchased Peplow Hall in Shropshire, from where he travelled daily by train to Silverdale and from there in his own private coach by mineral line to Apedale. He retired a very wealthy man in 1890 and the Stanier interests were broken up.

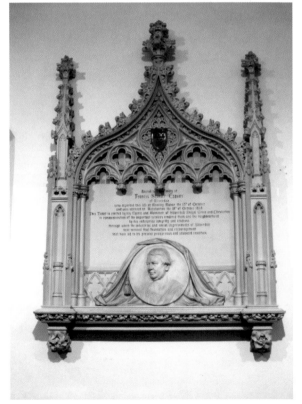

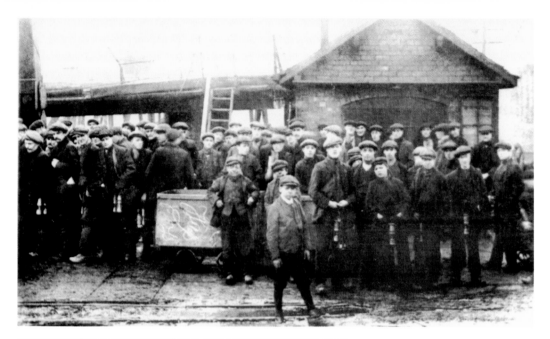

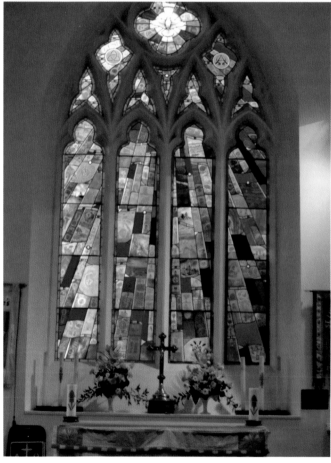

Children and the Mines

The east window of St Luke's was designed using ideas put forward by local schoolchildren. It shows scenes from Silverdale life. The children who designed this were not much younger than some of the pit boys in the old picture. An example is that of Joseph Cook, who we will meet later and who first worked in the pit at the age of nine in 1869.

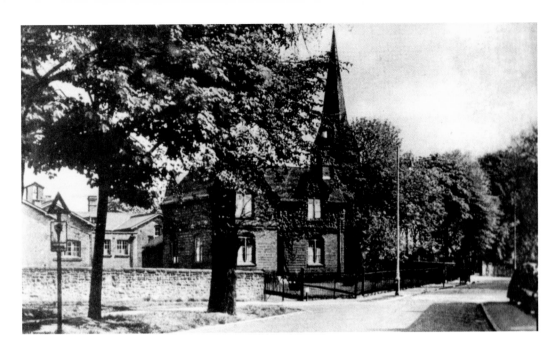

St Luke's Church of England School

The church school is seen in the old photograph, built in 1847 next to St Luke's. As was the case in Chesterton and Knutton, the population of the village increased in the second half of the century and new board schools had to be built. The church school served the community for many years and was eventually closed and demolished. The site is now occupied by Brighton House, built by Newcastle Borough Council as a home for the elderly.

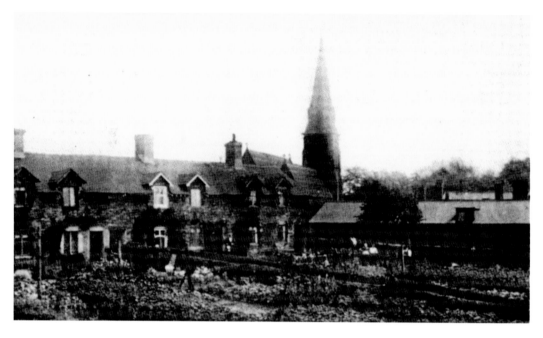

The Brighton

The area known as the Brighton is situated at the end of Station Road, tucked away between St Luke's church and Silverdale railway station. In the picture taken in the 1920s, the Brighton was occupied by a row of old stone cottages. Like the Gothics, the cottages were demolished in the 1960s and have been replaced by a row of bungalows for retired people.

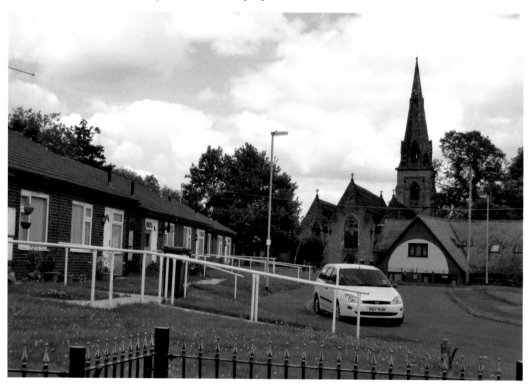

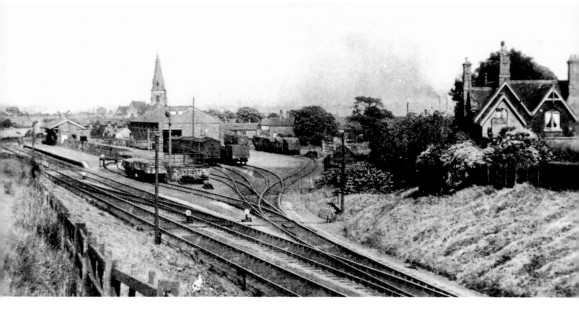

Silverdale Station I

The first railway to be built between Silverdale and Newcastle-under-Lyme was Ralph Sneyd's line in 1849. Then the North Staffordshire Railway (NSR) built a line that met Sneyd's at Knutton in 1852. A branch railway to Apedale was opened in 1853. Later, the NSR line to Silverdale was extended to Market Drayton. This opened for freight and passengers in 1870. These lines, along with numerous links into the collieries and ironworks, played a key role in the development of the industries of the area. The old picture here shows the busy Silverdale station in around 1918, with St Luke's church in the background and the stationmaster's house on the right. All that remains of the station today are the platforms and the bed of the track.

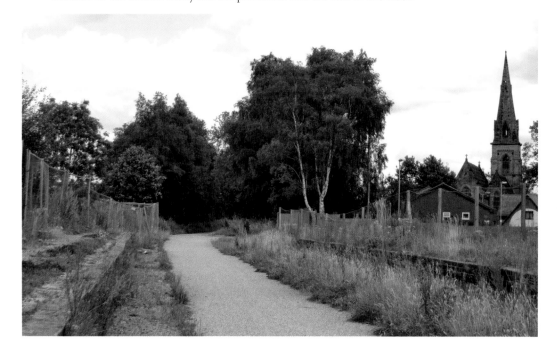

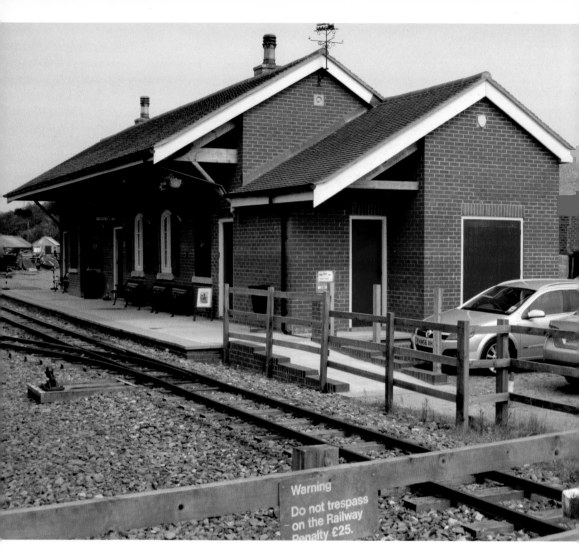

Silverdale Station II

This photograph shows the 'rebuild' of the station, situated at the Apedale Heritage Centre, using, where possible, materials rescued from the original station. These include stone window ledges, window frames, door frames and some of the internal brickwork. The passenger services on the Newcastle–Market Drayton line closed in 1964 but a single line for freight remained, to link Silverdale with the West Coast Main Line via the Madeley Chord.

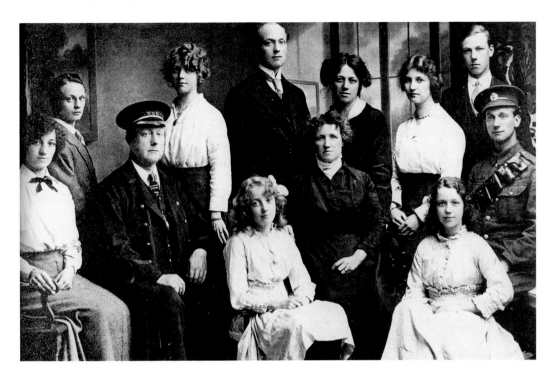

The Stationmaster's House

As the new photograph shows, the stationmaster's house remains. The old picture is a splendid family portrait of the stationmaster, John Peake, his wife and ten children. It was probably taken at the time of the First World War, when one of the sons had joined the Army. Mr Peake and three of his sons all worked for the North Staffordshire Railway.

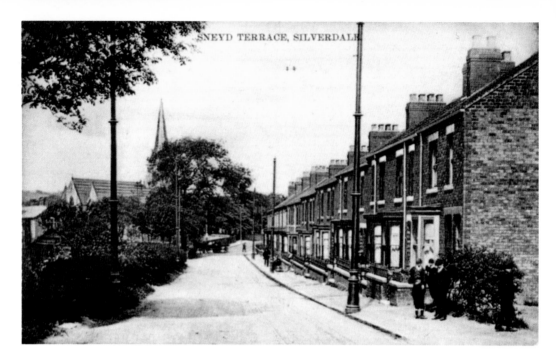

Sneyd Terrace

Sneyd Terrace is shown here running down towards Station Road and St Luke's church. The appearance of the houses on the right in both pictures shows little change. The bay windows and small front gardens with iron railings, now replaced by walls, suggest housing for the better-off working class. Harold Brown describes this west end of Silverdale, to which his family moved, as 'the pleasant outer edge of the village'. As the recent picture shows, there has been modern housing development on the left-hand side of the road.

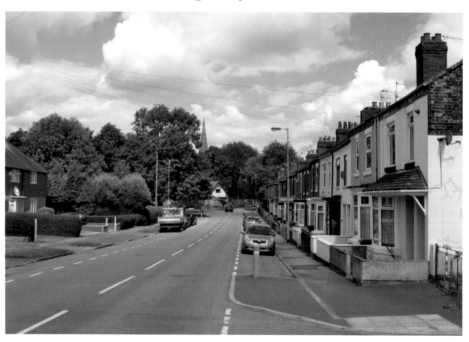

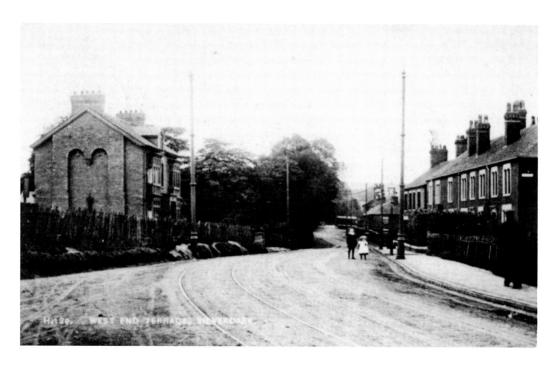

West End Terrace

West End Terrace is situated at the end of the High Street and this view is taken looking west, with Kinsey Street to the right. The terraced houses on the right of the old picture remain but the scene on the left has changed, with the building of modern properties. In the old picture, taken around 1910, the tramlines are clearly visible. Tram services from Newcastle to Silverdale began in 1901 along two routes – along Church Street and Sneyd Terrace and along Mill Street and High Street, with both lines meeting at the Sneyd Arms, just past West End Terrace. The tram services finished in 1926.

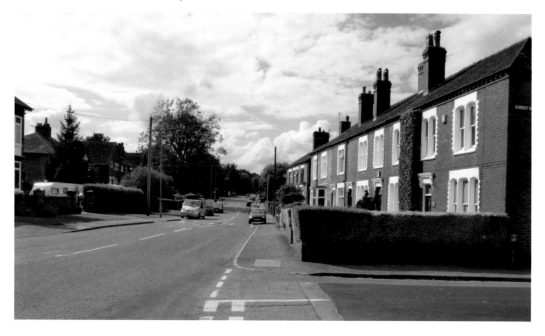

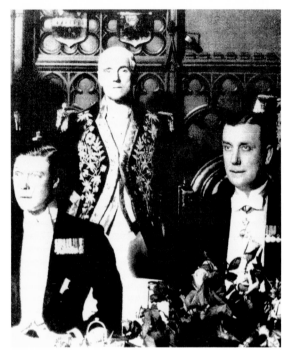

The Villas and the Cadman Family

The Villas remain substantial nineteenth-century houses at the west end of Silverdale. The blue plaque on the right-hand house marks it as the birthplace of John, later Lord, Cadman in 1877. His father was general manager of the Silverdale coal and ironworks and later president of the Institution of Mining Engineers. John had a distinguished career – from assistant manager in Silverdale Colliery, mines inspector in this country and then abroad, professor of mining at Birmingham University, and later important roles in both the oil industry and the development of the British aviation industry. In 1937, he was made a peer, Lord Cadman of Silverdale. He died in 1941. He kept his links with Silverdale throughout his life. He is pictured alongside the then Prince of Wales at the Guildhall in 1922.

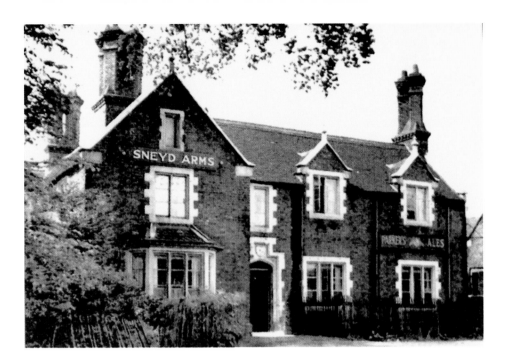

The Sneyd Arms

The by-now familiar name of Sneyd is a reminder of the influence of that family on Silverdale. The name of the public house has in fact changed, as the two pictures indicate – it has been the Bush as well as the Sneyd Arms. However, the building, situated at the west end of the village, retains its earlier appearance. It was here that Cadman celebrated his twenty-first birthday in 1898.

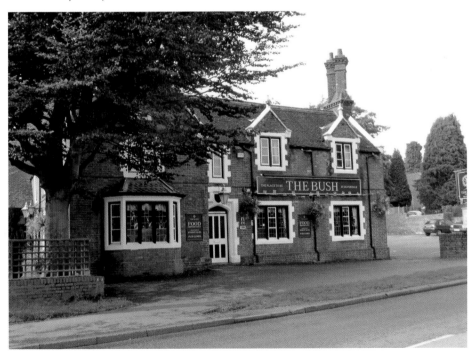

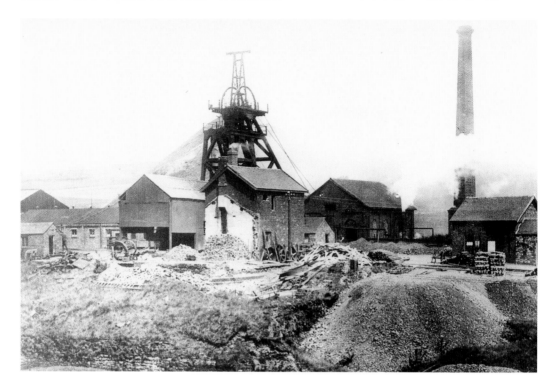

Silverdale Colliery I

The old photograph shows the colliery just after the First World War. The picture shows the rail sidings, the pithead, the smoke – a depiction of a busy colliery at work. Scenes like this led one visitor to Silverdale in 1950 to observe: 'Silverdale tucked away in its valley has the air of a South Welsh mining village.' The new photograph is a reminder of the very considerable output of the colliery right through to the period before closure. The plaque shows record production; 'in the years 1987, 1988 and 1989 the saleable output exceeded 1 million tonnes in each of the three successive years'. The plaque now resides in a display in the church.

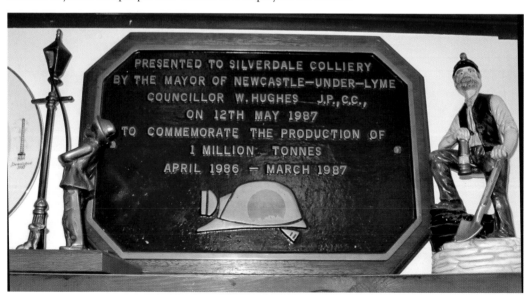

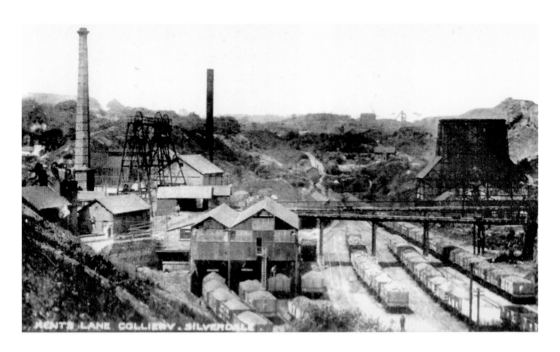

Silverdale Colliery II

The first shafts of Silverdale Colliery were sunk in the 1830s. It has always been better known locally as Kent's Lane Colliery, in spite of being renamed Silverdale Colliery in 1923. It played a large part in the history of the village until it was finally closed in 1998 – the last deep pit to close in the North Staffordshire coalfield. It was situated close to the church and next to the station. The site, as the modern picture shows, is presently having a complete transformation into a large housing estate.

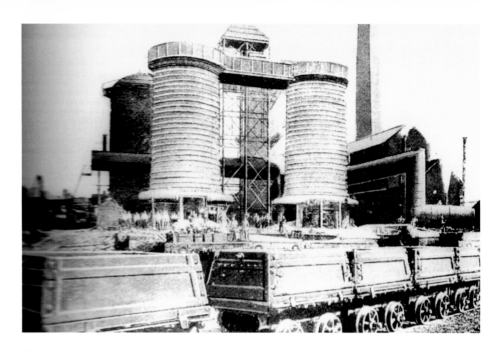

Silverdale Furnaces

The extensive iron furnaces were situated on the Scot Hay road leading out of Silverdale in a westerly direction. Now, all is much quieter and the site is occupied by the Enterprise Park and, in the new picture, Furnace Pool, run by an angling club. The ironworks dated from 1792 when Ralph Sneyd leased his collieries and land to the Silverdale Iron Company. The fortunes of the iron industry fluctuated widely in the nineteenth and early twentieth centuries. Its most prosperous period was under the control of the Staniers, father and son, after 1851. There was a downturn in the 1880s and the works were let by the Sneyd estate to Buttertons, a Derbyshire company. The picture here was taken during their period in charge, which ended in 1902, and was effectively the end of the operation.

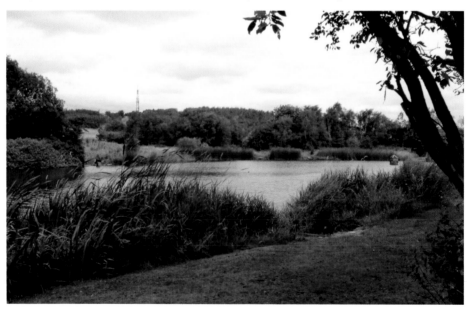

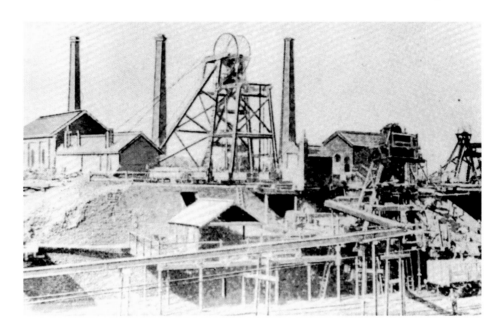

The Big Pit, Silverdale

The Big Pit, situated just past the furnaces, was a combination of two pits, Nabs and Sheriff. Along with the furnaces and other pits in the area, this part of Silverdale was described in 1856: these works were 'gradually converting a beautiful, picturesque valley, worthy of the name Silver Dale into a smoke-beclouded chaos' (*Mining Journal*). The recent photograph suggests that some of that former beauty is returning in the shape of the Silverdale Community Country Park. This attractive scene was formerly part of the site of the Big Pit.

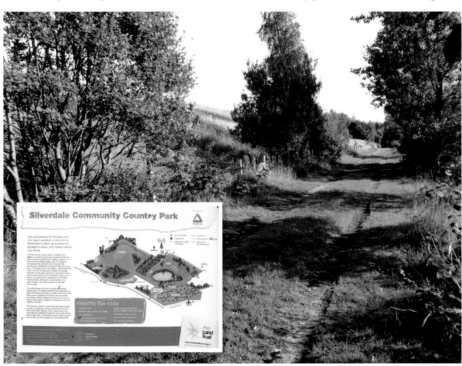

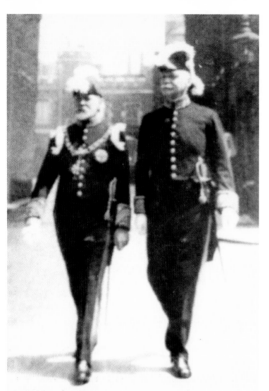

Miners' Houses

The new picture shows an attempt (in Silverdale church) to recreate the interior of a miner's house in the nineteenth century. Another example can be found in Apedale Heritage Centre. These reconstructions can be matched against descriptions like that of Harold Brown in his *Most Splendid of Men*. Another man from Silverdale who experienced this home background was Joseph Cook. He was working in the Big Pit in 1872, when he was twelve years old. His father, working in the same pit, was killed there a year later, leaving Cook as the main wage earner. Largely self-educated, he left Silverdale in 1885 for a mining job in Australia. He entered politics through the trade unions and at the age of fifty-three became Prime Minister of Australia – another remarkable career. He eventually became High Commissioner for his adopted country and is seen here in all the pomp of his post.

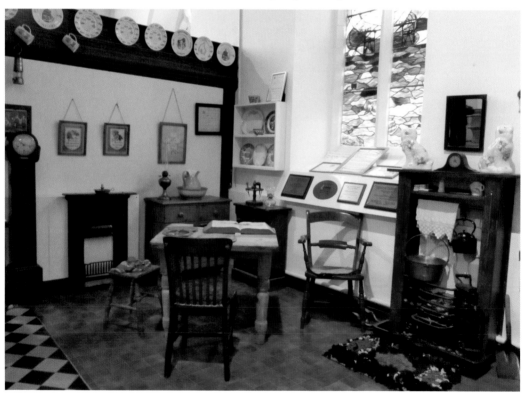

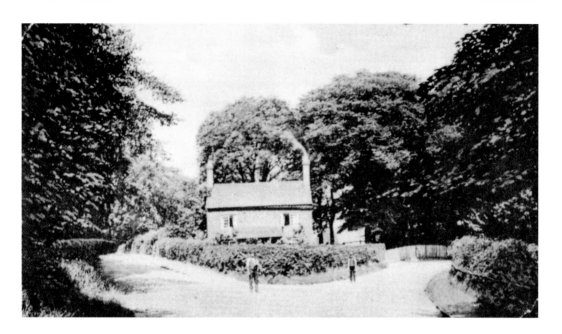

Pepper Street

Returning along Scot Hay Road to the village, Pepper Street (formerly Red Heath Road) is a road to Keele, the home of the Sneyds. The photographer in the old picture (*c.* 1908) had his back to Keele. The cottage in the centre of the picture remains but the road to the left is less obvious. To the right of the new picture is Underwood Road, a modern development. Pepper Street continues and emerges opposite the site of the former Silverdale Colliery.

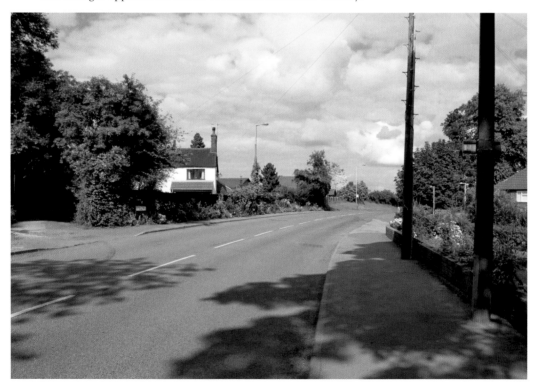

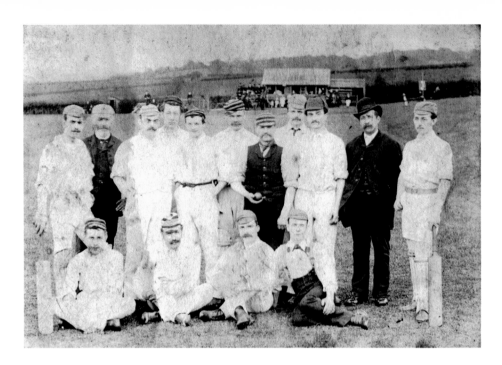

Silverdale Cricket Club

A diversion along Underwood Road arrives at the ground of Silverdale Cricket Club. The Siverdale Cricket Club was founded in the nineteenth century after a meeting between Francis Stanier and Ralph Sneyd at Keele. The old picture (undated) shows an early team with an attractive array of clothing and moustaches! The new photograph shows the pavilion, which dates from 1922, though the tiled roof is new. This long-established club continues to thrive in the present day.

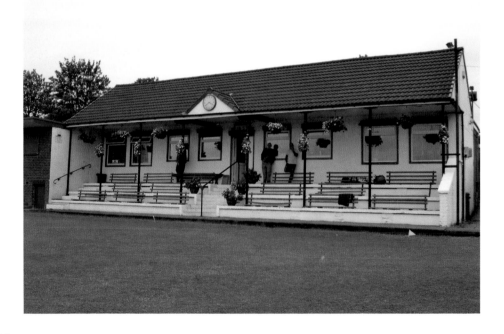

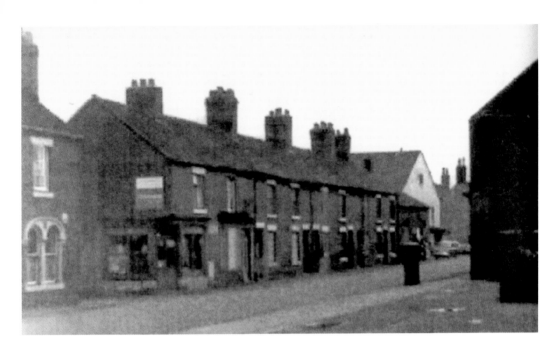

High Street, Silverdale

Considerable changes have taken place in the High Street, particularly in the central area. The older photograph shows the group of buildings from the corner of the Vine public house. As the modern picture reveals, the Vine remains but the other buildings, including the Roxy Cinema at the end, have gone. The new buildings include the Working Men's Club and the library. Beyond the trees is the open area, with a parade of new shops and the park to the left.

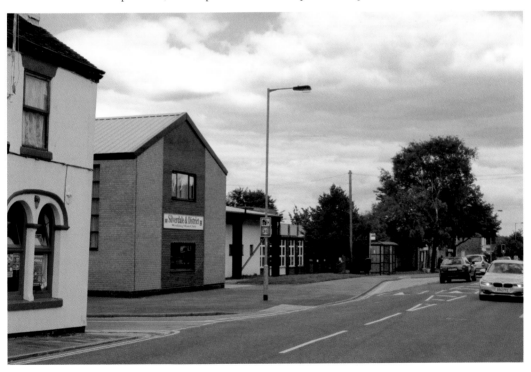

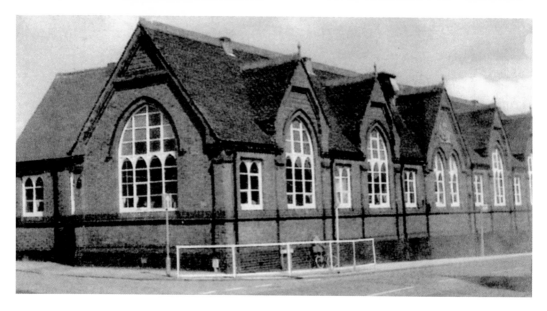

Infant and Junior Schools

The schools shown here were often referred to as board schools, long after control had passed from the Board of Education to local authorities. The only surviving 'board school' building is the one shown in the new picture here. Now used as a social centre, it housed the infants. Across the road, and shown in the old picture, was the junior school, originally with separate entrances for girls and boys. Nowadays the modern primary school is situated in Pepper Street.

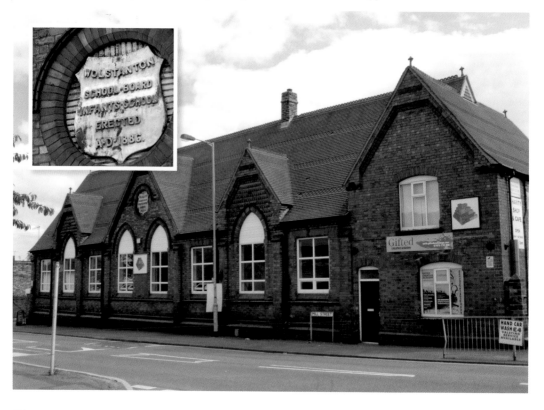

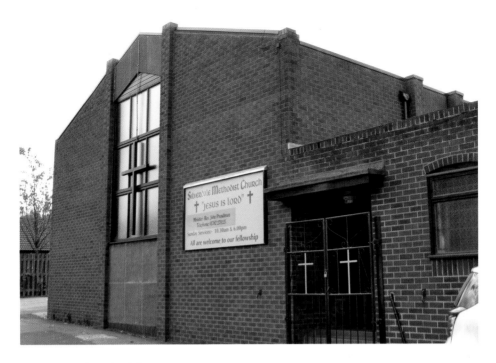

Methodist Chapel, High Street

There were four Methodist chapels in nineteenth-century Silverdale: the Wesleyan chapel in Newcastle Road, the Bethel chapel in Church Street, the Zion Primitive Methodist chapel and the United Methodist Free Church chapel in the High Street. Only the last one has survived. It is shown here in its present guise as a sports club. There is only one Methodist chapel now. The new building in Earl Street is shown here.

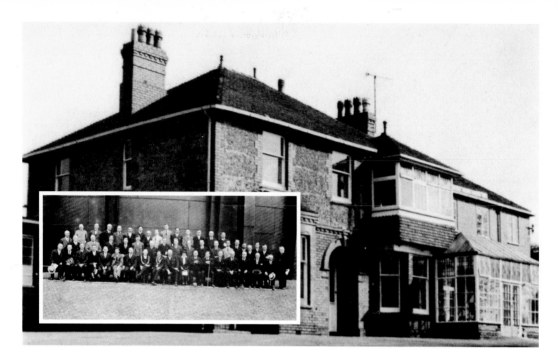

Fanny Deakin

Returning to the Miners' Memorial, there is one plaque on its side depicting a woman, Fanny Deakin. Still well remembered, she became a councillor in 1923 on Wolstanton Council, the first woman elected, as the old photograph makes very clear! She always campaigned on issues that she felt particularly affected the mining community in the 1920s and 1930s when she joined the Communist Party. One of her greatest achievements was the setting up of proper maternity care for women at what was named the Fanny Deakin Maternity Home in Chesterton. It was opened in 1947, but is now demolished.

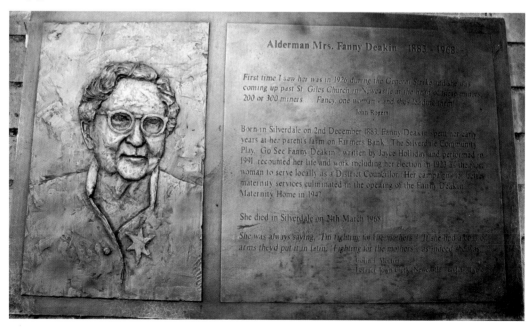